HORACE WALPOLE'S CAT

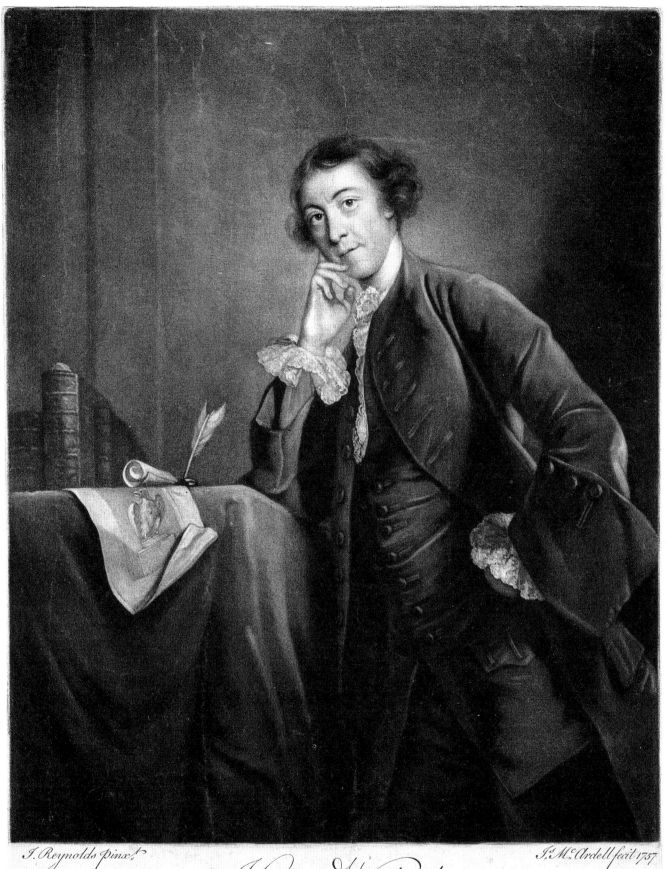

J. Reynolds pinxt. J. McArdell fecit 1757

Horace Walpole

Youngest Son of Sr. Robt. Walpole Earl of Orford.

HORACE WALPOLE'S CAT

Christopher Frayling

Illustrated by
Richard Bentley, William Blake
and Kathleen Hale

Thames & Hudson

Frontispiece *Horace Walpole: a mezzotint by James McArdell, 1757, engraved as a 'private plate' after a portrait of the same year by Joshua Reynolds. Walpole is presented as a gentleman of letters – although he did not yet have much of a reputation as a writer – and a collector, with a print on the table of an ancient Roman marble eagle which he had acquired on his Grand Tour. He was fond of animals and birds in art. The lace of his shirt and the ruffles of his sleeve are emphasized by Reynolds.*

First published in the United Kingdom in 2009 by Thames & Hudson Ltd, 181A High Holborn, London WC1V 7QX

thamesandhudson.com

British Library Cataloguing-in-Publication Data
A catalogue record for this book is available from the British Library

ISBN 978-0-500-51491-7

Printed and bound in China by C&C Offset Printing Co. Ltd

CONTENTS

❧

6 .. Prologue

8 .. Hodge

12 .. Patapan

17 .. Selima

24 .. A Favourite Cat

30 The First Designs: Richard Bentley (1751–52)

40 .. This Lofty Vase

44 .. Tailpiece

54 William Blake's Watercolours (1797–98)

66 Kathleen Hale's Illustrations (1944)

77 .. Notes on the Illustrations

78 .. Select Bibliography

79 .. Index

❧

PROLOGUE

The seeds of this book were planted way back in late 1960s Cambridge, when I was researching the politics of Jean-Jacques Rousseau's fiction – especially *La Nouvelle Héloïse* and *Emile*. Art and politics had become an urgent and fashionable area of study following the events of May 1968 in Paris. My supervisor was Ralph Leigh, editor of the astonishing multi-volume *Correspondance complète de Jean-Jacques Rousseau* – which not only contains all the known letters written *by* Rousseau, but all the known letters written *to* him as well as letters written *about* him. Whenever I visited Ralph for a tutorial in his rooms on the corner of Trinity College's Great Court, the College tabby cat – called Hodge – seemed always to be in evidence, lying demurely on the staircase in winter and on the grass outside in summer. I don't think I ever once saw Hodge in motion, over several years of tutorials. Ralph was a staunch admirer of Samuel Johnson (and of his robust conversational style, which he sometimes emulated), and wrote a celebrated talk about 'Boswell and Rousseau' from which the

impressionable James Boswell emerged without much honour. But Ralph Leigh's party-piece, after formal dinners at Trinity, was to recite by heart Thomas Gray's poem, *Ode on the Death of a Favourite Cat, Drowned in a Tub of Gold Fishes*.

Part of my research was about Horace Walpole's spoof letter purporting to be from the King of Prussia, Frederick the Great, to Rousseau (December 1765) – offering a sanctuary where the philosopher could be miserable to his heart's content – which deeply upset the already unbalanced Genevan during his stay in Wootton Hall, Staffordshire, between spring 1766 and spring 1767, when the letter was being much discussed in public prints. I had been interested in Horace Walpole's correspondence, and especially his attitude to art and design, since taking a special subject about 'George III and the Politicians' with Herbert Butterfield in 1967–68 as part of my History degree. When my thesis on Rousseau was finally submitted, Walpole ended up on the cutting-room floor. Like most doctoral theses, it had become something of a slog during

its final stages – 'just writing up' was the weary response to the inevitable questions about its progress – and when the thesis was completed, the last thing I wrote was the page of dedication: 'For George'.

I dedicated my thesis on Rousseau to my twenty-six-year-old goldfish, who was called George, because somehow, I felt, George's monotonous existence in his goldfish bowl, swimming round and round a sunken miniature castle (he had been given a specially large bowl on his twenty-first birthday) had certain resemblances with my own. I, too, had seemed – during dark moments – to be going round and round in circles without achieving very much, as I was 'just writing up' the lengthy thesis. The submission of my thesis had a happy ending. George, on the other hand, died shortly after the *viva voce* examination, and I duly amended the page of dedication in the University Library copy of the text to read 'For George – in piam memoriam'.

Hodge – Samuel Johnson – Thomas Gray's poem – Horace Walpole – my goldfish George – in memoriam: in retrospect, the story was all there. It has taken me all this time to see the connections.

Much more recently, advice from Michael Snodin, of the Victoria & Albert Museum, London (a Horace Walpole specialist), Tim Mowl (writer on Walpole, as well as an invigorating guide to eighteenth-century architecture), Rose Kerr (ex-V&A, an expert on Chinese ceramics), Kevin Jackson, of University College London (a Dr Johnson specialist), and Janice West (of the City of Westminster Archives Centre) helped in the development of this book, at crucial stages. Thanks to The Rt Hon. The Earl of Derby for the images of Horace Walpole's Chinese tub, to David Alexander for the mezzotint portraits of Horace Walpole, Samuel Johnson and Thomas Gray, to the Yale Center for British Art, New Haven, for William Blake's watercolours, and to the estate of Kathleen Hale for permission to reproduce her illustrations to Gray's poem.

The book is dedicated to the memory of Ralph Leigh, a great scholar. Also to Helen, who really understands cats.

HODGE

It has often been claimed that there are two kinds of people in the world – cat people and dog people. Dr Samuel Johnson – talker, moralist, clubland hero and celebrated lexicographer – gave a broad hint to his readers in the entries for 'cat' and 'dog' in Volume I of *A Dictionary of the English Language*, first published in April 1755, that he was by strong inclination a cat person. Not so much in his definitions – which, it has to be said, do not tell us very much about either animal, although they do have a noble gravity about them – as in the examples of particular usages he selected as quotations.

CAT. A domestick animal that catches mice, commonly reckoned by naturalists the lowest order of the leonine species.

> 'Twas you incens'd the rabble:
> *Cats*, that can judge as fitly of his worth,
> As I can of those mysteries, which heav'n
> Will not have earth to know.
> *Shakespeare, Coriolanus*
> Thrice the brinded *cat* hath mew'd.
> *Shakespeare, Macbeth*
> A *cat*, as she beholds the light, draws the ball of her eye small and long, being covered over with a green skin, and dilates it at pleasure
> *Peacham on Drawing*

DOG. 1. A domestic animal remarkably various in his species; comprising the mastiff, the spaniel, the bulldog, the greyhound, the hound, the terrier, the cur, with many others. The larger sort are used as a guard; the less for sports.

> . . . As knowing nought, like dogs, but following (Shakespeare, *King Lear*)
> . . .

3. A reproachful name for a man.

4. *To give or send to the Dogs*, to throw away.

5. *To go to the Dogs,* to be ruined, destroyed, or devoured.

6. *Dog* is a particle added to any thing, to mark meanness, or degeneracy, or worthlessness; as, *dog* rose.

7. *To Dog.* To hunt as a dog, insidiously and indefatigably.

> I have *dogg'd* him, like his murtherer. (Shakespeare)

If language was the dress of thought, as Johnson contended, these usages of the English language from Shakespeare's time to his own certainly seemed to have a thing about dogs. Under 'CAT', we read of the animal's powers of perception, of the mewing of a brinded cat (cross-referenced to 'TABBY'), and of cats' eyes dilating at pleasure – a feature later to be celebrated in W. B. Yeats's poem 'The Cat and the Moon'. Today, we know that the 'green skin' or membrane is in fact used for protection rather than pleasure, but it was a good story. Under 'TABBY' we find 'Brinded, brindled; varied with different colours. *A tabby cat sat in the chimney-corner* (Addison) / *On her tabby rival's face / She deep will mark her new disgrace* (Prior)'. The cat, then, is a practical creature with the heart of a lion. Under 'DOG', on the other hand, we read of blind obedience, reproaches, degeneracy and even (by association) murder. When he was preparing

his *Dictionary*, in the garret at 17 Gough Square just north of Fleet Street, which also served as a library, it is more than likely that there was also a cat in residence. In real life, Johnson was most definitely a cat person. In one of his most angry essays, he attacked medical researchers who experimented on animals as 'a race of wretches' who scarcely deserved to be called human beings.

The cat which was immortalized in the Scotsman James Boswell's *Life of Samuel Johnson, LLD*, published later in the century, was called Hodge, a word used in the eighteenth century as a typical and affectionate name for a good old English agricultural labourer or countryman. 'Hodge' was originally an abbreviation of Roger, and the tradition of applying the name to a rustic went back at least as far as Chaucer. A heart of oak. Johnson's tabby cat, on whom he doted with uncommon 'indulgence' in his middle years, was given an honourable mention in the *Life*, despite the fact that Boswell himself had an 'antipathy' (maybe even an allergy) to the animals. 'I never shall forget the indulgence with which he treated Hodge . . . I am, unluckily, one of those who have an antipathy to a cat, so I am uneasy when in the room with one.' Cats, Boswell thought, had an air of contemptuous knowledge, and this put him off them. On one occasion, Boswell, on seeing Hodge scrambling his way up the north face of Johnson's belly in a very affectionate manner, while the Doctor 'smiling and half-whistling, rubbed down his back, and pulled him by the tail', remarked on how fine the cat seemed to be. Johnson replied, 'why, yes, Sir, but I have had cats whom I liked better than this'.

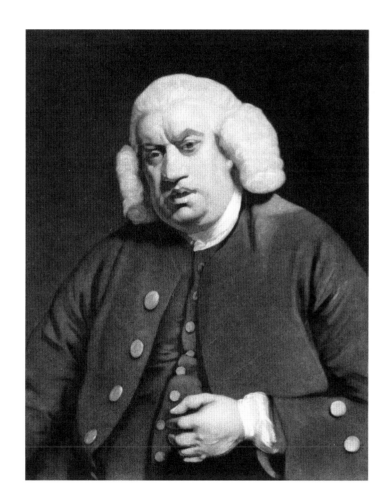

Dr Samuel Johnson, 'the great bear': mezzotint by William Doughty, 1779, after the portrait by Joshua Reynolds, 1772. His gruff appearance, Edward Gibbon later wrote, was misleading.

Then, as if perceiving that Hodge was a little 'out of countenance', he immediately added for the cat's benefit, 'but he is a very fine cat, a very fine cat indeed'. On another occasion, Johnson tells Boswell about some feckless young gentleman of good family who has been reduced to such depths of depravity that he was last seen 'running about town, shooting cats'. At which point Johnson picks up Hodge and strokes him reassuringly: 'But Hodge shan't be shot; no, no, Hodge shall not be shot.'

One of the indulgences shown to this much-loved cat was that his owner would go out specially to Houndsditch market and buy him oysters. Oysters were not yet the extravagance they sound today – they were very cheap in mid-eighteenth-century London – but still. . . Johnson would rise early, which he much disliked doing, and go in person down to the fishmarket rather than send his faithful Jamaican-born valet and secretary Francis Barber or other servants on the errand, for he was concerned that the servants 'having that trouble should take a dislike to the poor creature'. He did not want them to think for a moment they were being retained for the convenience of a mere quadruped. Johnson's domestic arrangements were chaotic, and his personal appearance often slovenly, but where Hodge was concerned he was happy to put himself out. When Hodge was dying, Johnson went out specially to find him valerian plant, to make his last hours more bearable. Johnson was a famous curmudgeon when conversing with fellow human beings, but indulgent with his cat. Or cats. His reference to 'cats whom I liked better' suggests a succession of earlier animals living with

Johnson and his wife Elizabeth in their London residences before the Hodge era of the late 1760s. We don't know their names, but we do know of one of them (from Hester Thrale's reminiscences) that Johnson said he 'once chid my Wife for beating her Cat before the Maid, who will now say I treat Puss with Cruelty perhaps – and plead at last her Mistress's example'. Edward Gibbon later wrote of Johnson that he had 'nothing of the bear but the skin': in other words, a gruff appearance but a pussycat within. The gruffness came from the fact that he was ill-at-ease socially – scarred by scrofula on his neck, half blind in one eye, with a nervous twitch – and that he was convinced England was going to the dogs. Today, there is a large statue of Hodge on an incised plinth opposite 17 Gough Square: the cat is sitting on a volume of the *Dictionary of the English Language* with an open oyster-shell in front of him. The inscription reads 'HODGE – a very fine cat indeed'.

Horace Walpole – author, collector, letter-writer (of four thousand *surviving* letters), design guru, youngest son of Sir Robert Walpole, the longest-serving Prime Minister of his day who governed fairly continuously from 1721 to 1742 – came to dislike Dr Johnson intensely on just about every ground there was: personal, aesthetic, social and political. He made no secret of the fact, whenever the occasion arose: his choicest insults include 'saucy Caliban', 'tasteless pedant' and 'Demagorgon'. So *unstylish*, and a 'Jacobite sympathizer' to boot. Horace Walpole, in fact, declined Dr Johnson's acquaintance when they nearly met. According to Boswell, though, Johnson for his part did not have much to say about

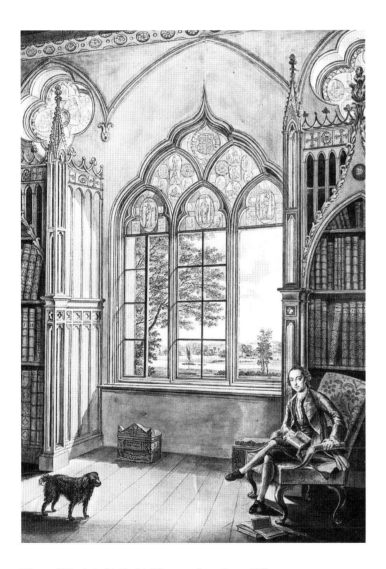

Horace Walpole in his Gothic library at Strawberry Hill, complete with his spaniel Rosette: watercolour by Johann Heinrich Müntz, who was employed by Walpole from 1755 to 1759.

Walpole, except that 'Horry' did put together 'a great many curious little things, and told them in an elegant manner'. Johnson had a strong antipathy to Walpole, because he was the son of a Whig minister, a Cambridge man, and foppish in his appearance. The musician Dr Charles Burney later wrote that 'the elements of fire and water cannot be more hostile to each other than this pair'. One thing they had in common was a love of cats. One thing they didn't have in common was that Horace Walpole was even more fond of dogs – preferably small, yappy lapdogs. Indeed, it was often observed of him that he was much better at giving affection to his animals than he was to the real persons in his life and, further, that he particularly enjoyed the *unconditional* devotion given to him by creatures with whom he felt completely at ease socially... Hence, his preference for dogs.

PATAPAN

When Horace Walpole was growing up, his father and his mother (the wealthy Catherine Shorter) had a taste for being painted, surrounded by small dogs, paintings and *objets d'art*, with their Palladian country house, Houghton Hall in Norfolk, proudly displayed in the background: an ancient family as well as Norfolk farming stock. Horace inherited the taste for pets, paintings and *objets d'art*, though – as a younger son – not the Hall, which in any case he thought vulgar, the very opposite of his idea of a stylish home, although he completely understood its symbolic significance. Robert and Catherine crammed Houghton to the rafters with some four hundred pictures, including Van Dycks and Rembrandts. The young Horace refined his writing skills by cataloguing them, and by fending off political enemies who wondered aloud how on earth the Prime Minister had managed to pay for them. A portrait of Sir Robert Walpole hangs to this day in the Cabinet Room of 10 Downing Street, just above the Prime Minister's chair.

But Horace was not always lucky with his pets. In fact, they seem to have had an unusually high mortality rate. Another wit was to ask whether it may perhaps have been more a case of the pets being unlucky with Horace. Whatever the truth of the matter, the first piece of bad luck occurred in autumn 1739 during his Grand Tour, his rite of passage in search of antiquities and partying, through France and Italy. On the outward leg of this Tour, which took them to Calais, Paris (where Horace couldn't resist noting that French opera 'resembles a gooseberry tart as much as it does harmony'), Rheims, Dijon, Lyon and the mountains of Savoy, Walpole was accompanied by the apprentice poet, or possibly lawyer,

scholar, graduate of Peterhouse (through he didn't complete his degree) and his chief literary correspondent, Thomas Gray. They had been rather bookish schoolfellows, and very close friends, at Eton together, and Gray was travelling as Horace Walpole's guest – a fact of which Walpole in moments of stress liked to remind him, as but one example of their social differences. Added to which the quiet, withdrawn, fastidious, socially insecure Gray was much more of a sight-seer, antiquarian and note-taker than Walpole, who much preferred to socialize. They started arguing at Calais. It was between France and Italy, on their way to Turin in the precip-itous valley of the River Arc up towards the pass of Mont Cenis, that Horace, a lifelong Whig, let his pet black-and-white King Charles spaniel called Tory – a dog he'd been given by his cousin and fellow Old Etonian, Lord Francis Seymour Conway, before they left Paris – out of the *chaise* for a comfort break. It was an unusually sunny day and the dog could have a run-around with the slow-moving horses. Then something very dramatic happened, as he recalled: 'There darted out a young wolf, seized poor Tory by the throat, and, before we could possibly prevent it, sprang up the side of the rock and carried him off . . . It was shocking to see anything one loved run away with to so horrid a death.' Gray preferred to describe the villain of the piece as 'a great wolf', and was much more concerned in *his* account of the incident about whether the wolf might harm the horses and in consequence cause the *chaise* to be tipped over the edge of the precipice. It was a fifty-fathom perpendicular drop. Both reactions were characteristic of the men who made them. Walpole recalled

Tory as 'the prettiest, fattest, dearest creature'. For a little while, he was very sad at this vexing distraction from the high experience of the sublime.

Then, as if that wasn't enough drama, on 18 May 1740 – by which time the two young companions had reached Reggio in the Duchy of Modena via Turin, Genoa, Bologna, Florence, Siena and Rome (between Siena and Rome, at an inn on Mount Radicófani, they had a supper so bad that Gray wrote to his mother 'your cat . . . sups much better than we did'), had had a long-simmering row about something or other, and had gone their separate ways – Walpole's dog Bettina tumbled over a hotel balcony onto the street below and died within three minutes: 'Is it not cruel,' he asked, 'to have all one's creatures come to such untimely ends?' His surviving spaniel would surely be desolated at the loss. As a consolation, he suggested that the survivor in question, his little white Roman spaniel Patapan – Bettina's close companion, given to him in Florence by Elisabetta Capponi, Marchesa Grifoni – be married off to the Empress Maria Theresa's youngest sister (who was indeed available) or in default of that, 'He shall go to England, where I shall get him naturalised and created a peer.' Only such extreme social measures could console Patapan as well as his flamboyant owner for the loss of the hapless Bettina. The 'peerless' Marchesa Grifoni was often to be mentioned in Walpole's despatches as 'a most beautiful [married] lady at Florence', who enjoyed young Horace's unthreatening and somewhat overacted attentions as a *cicisbeo* or romantic gallant – authorized by, as custom allowed, the Marchese Grifoni.

In summer 1743, two years after his return from the Grand Tour and a year after his father's somewhat unsavoury resignation from the House of Commons, during some long and more than usually boring afternoons at Houghton Hall, Walpole wrote a long, mock-heroic fairy-story in prose and verse, with political and vaguely pornographic interludes, some of them libellous, called *Patapan, or the Little White Dog*. It was, he put in his *Short Notes* for 1742–43, 'a tale imitated from Fontaine. It was never printed.' In fact, *Patapan* had to wait over two hundred years before being published, although the story was circulated widely in manuscript at the time among Walpole's political friends. The tale was based on Jean de La Fontaine's verse fable, *Le Petit Chien qui secoue de l'argent et des pierreries*, first published in 1671, itself based on passages from Ariosto's *Orlando Furioso*. In its 1671 version, it was about an amazing dancing dog called Favori – really the fairy Manto, founder of the town of Mantua, in disguise as 'the smallest dog that nature ever produced' – which could conjure 'pearls and rubies and diamonds' from its curly, silken white ear, whiter than ermine, and conjure up magnificent castles from thin air. The fable concerned Anselm, a jealous judge and magistrate from Mantua, Argie his beautiful bride, and Atis, a wandering paladin who is the love interest. The moral is about greed (Argie goes to bed with Atis, in exchange for the magic dog) and hypocrisy (Anselm, furious at his wife's infidelity, then agrees to pleasure a hideous-looking Ethiope – male – as his *enfant d'honneur* or page of honour in exchange for being given a sumptuous palace). Eventually, Anselm and Argie are reconciled, swearing to be faithful to

each other and less judgmental about other people's 'shameful acts' in the future.

> And what of the dog? Well, the dog did what the lover
> wanted.
> And what did the lover want? If you insist, I'll tell you:
> He wanted, with the dog's help, to try his luck elsewhere.
> Is one ever satisfied with a single conquest?
> So Favori strayed many times;
> But he always returned to his first mistress
> As a special friend . . .

In Walpole's version, which sometimes reads like a straight translation of the La Fontaine, if that's the right phrase, the action shifts from Mantua and Rome to Westminster and Ember Court in Surrey during King James I's reign; Anselm becomes the Speaker of the House of Commons, Arthur Onslow; the bride becomes the fictional Isabel, 'of suitable family, and very handsome'; and Atis becomes Horace's current fantasy-figure whom he had joined on the Grand Tour, the charming and manipulative Henry Fiennes Clinton, Earl of Lincoln, another fellow Old Etonian ('he was tall, well-made and his complexion of a manly brown. He had every feature and limb that promised strength and vigour; and his words promised a vast deal more . . .'). The fairy first announces herself to Henry thus:

> Fair Florence knows the wonders of my fame;
> Of fairy race, Grifona is my name.

(Grifona was, of course, inspired by the Marchesa Grifoni, who had given Horace the *real* Patapan in the first place.) There is much salacious satire, especially in the copious footnotes, mainly at the expense of Robert Walpole's many political enemies who had conspired to bring him down in the early 1740s with allegations of corruption and criminal mismanagement – but for our, and Horace's, purposes the key character is the dog, or rather Grifona disguised as the dog, Patapan. As she explains to Henry, to accelerate his seduction of Isabel,

> . . . first to soften this imperious dame,
> To wake her fondness and her pride to tame,
> A small queer cap'ring dog I will become,
> And like a weary pilgrim you shall roam.

When the nurse first introduces Patapan to her mistress at Ember Court, she exclaims: 'Oh, Madam, the King of Spaniels! a little jewel! an angel if ever there was one upon earth! the sweetest little dog! I'll warrant you he has more wit in his little finger than I have in my whole body . . . !' To which Walpole appends a helpful footnote at the word 'angel': 'This expression of the nurse's, was in reality a common one of the author's about Patapan.' But Henry, in his disguise as a mendicant pilgrim, replies:

> Not to be given is my dog, nor sold;
> A treasure inexhaustible of gold,
> Supplies whate'er I want; whene'er I please
> Shakes pearls into my hand, instead of fleas.

There is, however, 'a kind of ready might pay his price' – a payment that he might be persuaded to accept – and that is 'one night with your lady', even though Isabel *is* the Speaker's wife. The lady relents, the hypocritical Speaker subsequently agrees to pleasure the unattractive Ethiope for two days as page of honour, and Isabel discovers the Ethiope and the Speaker *in flagrante delicto*:

> Is this, my dear, your senatorial trade?
> And thus go Speakers clad in masquerade?
> Is this soft couch your *chair*, and boasted place?
> And that same swarthy instrument your mace?
> Are these the *motions* that you make? Is this
> The joy that you prefer to wedded bliss?

After this poor Arthur Onslow is glad to accept any terms on offer, and mutual peace and forgiveness are sealed (Walpole is at pains to explain in yet another footnote that there is no 'reality in the catastrophe of the story'). What happens to the dog Patapan is not explained. The Ethiope changes into a fairy.

Horace Walpole's high-camp friend, the wit and connoisseur John Chute (one of whose forebears had been Speaker of the House of Commons), called the real-life spaniel Patapan a 'dear little Knight of the Silver Fleece' and even went one better than Walpole's design to have the dog made a peer by asserting that his own cat Geoffrey should formally adopt 'his little dear Highness Patapan' – 'settling his fortune upon him with this only other condition, that he conform himself to the Church of England, by law established'. Presumably the Florentine Patapan was thought to be a Catholic. Ten days after Patapan died of natural causes in April 1745, shortly after the death of Sir Robert Walpole – by then 1st Earl of Orford – Horace wrote: 'If it would not sound ridiculous, though I assure you I am far from feeling it lightly, I would tell of poor Patapan's death . . .' His beloved first cousin, the hearty and soldierly Henry Seymour Conway (brother of Francis, he of spaniel fame) wrote from the battlefield of Fontenoy, where six thousand British troops had just been slaughtered by the French, 'but what are all deaths to poor Patapan?'

Walpole's close correspondents had to be expert at involving themselves in his elaborate fantasy world, whatever the circumstances. But Patapan had been a particular favourite, to judge by the number of mentions in Walpole's letters: the celebrated painter John Wootton made his portrait, and both Walpole and Chute wrote florid poems in his honour. Part of the game was to project human attributes onto animals, and sometimes vice versa. In many ways, Walpole's pets – dogs *and* cats – resembled Sebastian Flyte's teddy-bear Aloysius in *Brideshead Revisited*, or animate versions of Linus's blanket. They were indeed the recipients of more genuine affection than all but a very select few of his friends. And they reciprocated with uncomplicated friendship. When they died, he was genuinely – if fleetingly – upset.

The fashion for such mock-panegyric verses as *Patapan* had been quietly launched by Alexander Pope, a few years before. For Pope, whose villa with its garden and grotto

had drawn attention to Twickenham and surroundings as a fashionable place for an artist as well as dowagers to live, had written in 1736 perhaps the first ever poem by a major British writer to be dedicated to his dog. The dog was called Bounce, and he was a Great Dane. In fact the diminutive, sickly and embittered Pope had owned several dogs called Bounce, and they were all Great Danes – the first having been acquired as a guard-dog against hostile critics and irritated fellow poets, of whom there were legion. The poem was called 'Bounce to Fop: An Heroick Epistle from a Dog at Twickenham to a Dog at Court' and it was couched in the form of a message in doggerel (of course) from Bounce to Lady Suffolk's spaniel, the courtly Fop:

FOP! you can dance, and make a leg,
Can fetch and carry, cringe and beg,
And (what's the Top of all your Tricks)
Can stoop to pick up Strings and Sticks.
We country dogs love nobler sport,
And scorn the Pranks of Dogs at Court . . .

Bounce (one of them) was however to achieve a certain immortality in Court circles, when his puppy was given to Frederick, Prince of Wales, at Kew Palace up the road, complete with two lines of Pope incised on his collar:

I am his Highness's dog at Kew.
Pray tell me, sir, whose dog are you?

Alexander Pope died in May 1744, two and a half years before Walpole went to Strawberry Hill in Twickenham – his then unattractive 'little plaything house' with five acres (some two hectares) of land beside the Thames. But, Walpole noted in June 1747, a month after signing the lease, 'Pope's ghost is just now skimming under my window by a most poetical moonlight.' The poet's villa was only a short distance away. This had presumably been one of the attractions. Another was that 'Dowagers as plenty as flounders inhabit all around'.

Walpole was to write other verse fables – such as *The Funeral of The Lioness* in summer 1751, and *The Magpie and Her Brood* in 1764 – but none so elaborate, or quite so scurrilous, as his homage to the white Roman spaniel Patapan. *The Funeral of The Lioness*, 'imitated from La Fontaine' (it is based on *Les Obsèques de la lionne*), is about the Lion Queen's state funeral and the refusal of a stag to be taken in by all the pomp; the King of Cats, head of the leonine species, pardons the stag and agrees as part of a happy ending that actions do indeed speak louder than words. In *The Magpie*, a slighter piece, mother Marjorie (or 'Madge') teaches her reluctant family to fend for themselves. This fable – 'turned in Gothic style' from 'the Tales of Bonaventure des Periers, Valet de Chambre to the Queen of Navarre', as the antiquarian Walpole could not resist adding – was dedicated to a neighbour, the ten-year-old Miss Henrietta Hotham of Marble Hill, Twickenham.

But ah! the charm must cease or soon or late,
When chicks and misses rise to woman's 'state.

SELIMA

But our story concerns a much smaller cat than the King – Walpole's cat, a tabby called Selima, one of two 'handsome cats' who lived in the London house at No. 5 Arlington Street, the lease of which Horace inherited in March 1745. Sir Robert had died in the house, and his youngest son had witnessed the great man's final, painful nights, which imbued the property with gothic memories. Arlington Street is a short street south of Piccadilly and parallel with St James's Street. The house had been built as part of the post-Restoration development of the area as a 'Court Suburb', in the late seventeenth century, on land granted by King Charles II. Horace Walpole had been born in No. 22 (some say No. 17); in 1742, when his father left office and with it 10 Downing Street, they moved to a smaller house at No. 5, 'opposite to where we formerly lived'. Arlington Street was for him 'from my earliest memory . . . the ministerial street', because so many members of the government tended to live there in the eighteenth century. No. 5 was on the east side of the street, the non-ministerial side, and Walpole wrote many years later, with several deliberate meanings, that 'I . . . shall always be on the wrong side of the way.' This 'middling kind of house' was a brick-built construction of three storeys plus a basement (it now presents a taller, late Georgian exterior). The drawing room was on the first floor. Sitting in the dining room on the ground floor, he could sometimes hear loud cries of 'Stop, thief!' from nearby Piccadilly. One of his possessions there was the Elizabethan magus John Dee's magic mirror, which he reckoned protected No. 5 from robberies. After Sir Robert died, Horace continued to use No. 5 as his pied-à-terre in town until autumn 1779, when he moved to

Berkeley Square, and joked from there about a 'new lease of life': 'I was born in Arlington Street, lived there about fourteen years, returned thither, and passed thirty-seven more.' No. 5 Arlington Street is now marked with a memorial plaque dedicated to 'Sir Robert Walpole 1676–1745 Prime Minister / and his son Horace Walpole 1717–97 Connoisseur and Man of Letters'. The 'ministerial' side of the street is today bookended by the Ritz Hotel at the Piccadilly end, Le Caprice restaurant at the bottom end. The original numbers 17 and 22 have gone. After Strawberry Hill was organized, Horace Walpole no longer considered Arlington Street his real home.

But Arlington Street *was* the home of Selima, Horace Walpole's tabby cat. In Samuel Johnson's *Dictionary*, the word 'tabby' was said to mean 'brinded . . . varied with different colours', or of a brownish colour, marked with darker stripes or streaks – a definition which dated from the final years of the seventeenth century. (Today, by the way, 'brinded' or 'brindled' cats tend to be *contrasted* with pedigree tabby cats, which should have more strongly defined markings.) But this was not yet the word's primary meaning. In the *Dictionary*, that was given as 'a kind of waved silk' or taffeta, originating in Baghdad.

This was where the word 'tabby' came from. But what of the name Selima? Was it an example of Walpole's taste for mock-oriental tales and oriental artefacts? Well, it is very likely that he acquired Selima in or around autumn 1746, because that was when he penned an *Epilogue* to Nicholas Rowe's then-popular play *Tamerlane* (written in 1701) – an epilogue which takes some explaining. Every year, on 4 and 5 November, the anniversary of King William III's birthday and of his

landing at Torbay in 1688 (leading to the end of the Catholic rule of James II), it had become the tradition, for as long as anyone could remember, to revive Rowe's tragedy. Tamerlane in the play was thought to resemble William, and his arch enemy Bajazet was identified with Louis XIV. But in 1746, when memories of the 1745 rebellion in Scotland in support of Bonnie Prince Charlie were still strong, there was another William to celebrate – William, Duke of Cumberland, the victor of the Battle of Culloden.

When *Tamerlane* was performed that year, 'at the theatre in Covent Garden', Walpole was commissioned to write a special *Epilogue . . . on the Suppression of the REBELLION*, to be spoken for a couple of performances by Mrs Pritchard in the character of 'the Comic Muse' – not a character in the play, which it has to be said is notably short of comic muses. The *Epilogue* was rushed into print on 5 November, and became one of Walpole's first big successes as a popular author. It is full of ingenious references to the Jacobite rebellion and the Battle of Culloden – not to mention abstruse citations of Virgil, Cato, Caesar and Brutus, and Pope – but its main theme was a sigh of relief that the stage was not after all to be censored by bigoted Catholic priests. So the piece begins:

> Britons once more in annual joy we meet
> This genial night in freedom's fav'rite seat . . .

Where Bonnie Prince Charlie was concerned,

> Chains, real chains, our heroes had in view,
> And scenes of mimic dungeons chang'd to true.

> An equal fate the stage and Britain dreaded,
> Had Rome's young missionary spark succeeded.
> But laws and liberties are trifling treasures;
> He threaten'd that grave property, your pleasures.

The heroine of the play is the fragrant Princess Selima, daughter of Bajazet, Emperor of the Turks. She has been captured by Tamerlane's troops, and falls in love with the dashing Prince Axalla, an Italian general who is also the 'Favourite of Tamerlane'. The main dramatic interest in the play is her divided loyalties. She is introduced as a 'Love-sick Virgin':

> The bloom of opening Flow'rs, Unsully'd Beauty,
> Softness, and sweetest Innocence she wears,
> And looks like Nature in the world's first spring.

But as the play develops, it becomes clear there is much more to her than 'sweetest innocence'. She strongly resents being held prisoner ('The Gifts of Captives / Mean somewhat of constraint'), and uses all her considerable wiles to save her father's life whatever the outcome of the battle, but when Axalla has been captured by Bajazet in Act III, she encourages him to lie ('Oh my Axalla, *seem* but to consent') to save *his* life. This infuriates Bajazet and nearly results in her death by strangulation when she helps Axalla to escape. Tamerlane arrives in the nick of time and gives instructions to his loyal Parthian general:

> Zama, take care, that with the earliest dawn,
> Those Traytors meet the Fate their Treason merits.

The star of the show is the furious Bajazet, who is forever railing against having 'a nauseous Courtesy forc'd on me' and cursing 'the vile Christian Dog'. Apart from him, *Tamerlane* is dominated by blustering heroes and weeping heroines. Samuel Johnson's verdict on it – 'occasional poetry must often content itself with occasional praise ... Our quarrel with Lewis [XIV] has been long over' – remains a just one.

So it is very likely that Selima the cat arrived in Horace's life at around that time. Selima in the play displays feline cunning, she *seems* a captive yet remains her own person, and – provided it is on her own terms – she shows great affection. Plus there were Horace's warm feelings of pride about the *Epilogue*, which he took the trouble to list in his *Short Notes* for 1746. Selima was one of a pair of cats. The other was called either Zara (after the heroine of *The Tragedy of Zara*, set in the Jerusalem of the Crusades, adapted in 1736 from Voltaire's play *Zaire*) or Zama (after the stalwart Parthian general in *Tamerlane*). There is some debate about the exact transcription of a manuscript, which has not survived. Zara in *The Tragedy* is a captive of the Sultan, who falls in love with her before going on to murder her in a fit of jealousy. But again, it may well be that the second cat was called Zama, that he arrived at around the same time as Selima, and that he was a tom, maybe even a brother. So not the maiden Zara, but the macho Zama. The only reference we have to Zara/Zama is in Thomas Gray's letter of 22 February 1747 as transcribed and bowdlerized by his fellow poet, the Rev. William Mason – the executor who produced the authorized version of Gray's biography in 1775 – and 'Zara' may have been a slip of Mason's pen. Or a misreading of Gray's writing. We know that Mason was persuaded to alter the wording of the letter so as not to upset refined sensibilities. Gray originally wrote 'Zara I know and Selima I know' – an arch parody of the Acts of the Apostles 19:15 – but Mason changed the passage to the duller 'I know Zara and Selima' because he objected or was persuaded to object to the 'idle allusion in it [the letter] to Scripture'. Maybe he got the name Zara wrong as well.

Another of Walpole's prized possessions in Arlington Street was a large blue-and-white porcelain Chinese tub, dating from *c.* 1730 – 18½ inches high and 21¾ inches wide (47 × 55 cm) with a pine, bamboo and plum-blossom motif and a blue band round the rim – which he used as a goldfish bowl. The colours of gold, blue and white must have gone well together. The pattern on the tub was and is known as 'the Three Friends of Winter'. The pine tree stood for venerable old age, the bamboo for bravery and strength of character (it may bend but never break), and the prunus for youth, beauty and the first appearance of spring. They are planted beside an ornamental rock and there is a latticed bridge as well. The 'Three Friends' grouping was often used in real Chinese gardens, and was a popular motif for luck. Where the tubs were concerned, such large high-fired Qing Dynasty porcelain pieces were mainly used in China for fish and lotus in small gardens. Sometimes they featured decorative goldfish in red, added to the characteristic blue and white design – fishes swimming in a lotus pond, seen through the transparent glaze. The blue-and-white decorative style had been around since the Yuan Dynasty of the late thirteenth century. But

✦✦✦✦✦✦✦✦✦✦✦✦✦✦✦✦✦✦✦✦✦✦

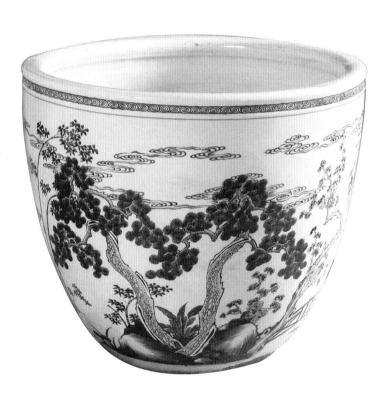

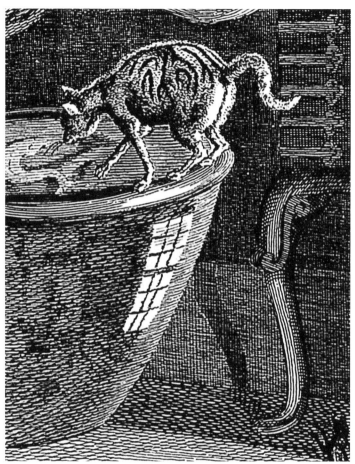

Horace Walpole used this blue and white Chinese porcelain tub, made c. 1730, at Arlington Street as a goldfish bowl. Its 'Three Friends of Winter' pattern features, from left to right, bamboo, pine, and prunus. (For another view of the tub, in colour, see p. 65.) A detail of one of Richard Bentley's illustrations to Gray's Ode *(see p. 34) shows the tub, the fish, Walpole's cat Selima, and the reflection from the window.*

large tubs of this kind only became available some three hundred years later. Before that, it proved impossible to fire them successfully. We know that attempts to fire large tubs in the fifteenth century had failed. One of the temples at the Imperial Factory at Jingdezhen was dedicated to the Potters' Deity, a potter who was fabled to have sacrificed himself by jumping into the kiln to safeguard the firing of these large pieces – unsuccessfully, as it turned out. Whether or not Horace Walpole was aware of the tub's symbolic significance, he used it at Arlington Street as part of his interior design.

Goldfish were a relatively recent craze, more recent than the craze for blue-and-white Chinese porcelain. They had been brought to England from China as ornamental fish in the late seventeenth century, around 1691, and by half a century later were still thought to be exotic and delightful enough to be suitable presents for a king's mistress: in France (where they arrived later than in England) Madame de Pompadour, no less, was presented with some. They were still on the level of luxury goods destined for the court. Dr Johnson's *Dictionary* in 1755 contains no reference to them: goldfinch and goldhammer yes, but goldfish no. The botanist Linnaeus was the first to classify them, in 1758, as *Cyprimus auratus* (*auratus* being the Latin for gold). Walpole was later to keep goldfish in a pond at Strawberry Hill he called Po Yang, after a lake in the Kiangsi province which was, he had read, well-known for its fish. One day, he brought them into the house during a summer downpour, to save the precious creatures from drowning, forgetting in all the excitement that they were fish! He also joked about two down-at-heel aristocrats dragging a goldfish pond, in the hope they might find some traces of gold: they would 'certainly burn the poor fish for the gold like old lace'. And he had several volumes about China and Chinese culture in his large Gothic library at Strawberry Hill (see p. 11), a collection which had begun in 1735 – the year he went up to King's College, Cambridge, when he had been given as a present the Jesuit missionary Jean-Baptiste du Halde's compendious *General Description of the Chinese Empire*, the standard sourcebook. It was in Du Halde that he found the Po Yang reference. Lord Hervey, who had given him the *General Description*, was slightly worried about the effect the book might have on the impressionable young man, writing a while later: 'you describe in a very entertaining manner the change it has made in you . . . I advise you if you can [though] to continue an Englishman.'

At that early stage in his life, Walpole was enthusiastic about the growing craze for blue-and-white porcelain, for China tea (which was well on the way to becoming a national beverage), for lacquer-work, and for the latest adaptations of Chinese motifs in architecture and garden design. But by the late 1740s, he was no longer so sure about the cult of Chinoiserie and the taste for the Chinese fringes of Rococo design. Chinoiserie was fun, it was light, it created surprise, and it had a 'whimsical air of novelty', but it was probably a stylistic cul-de-sac. Increasingly attractive to Horace Walpole was his almost equally whimsical version of the Gothic style, which had the advantage – he liked to think – of having English origins, a home-grown otherness; a different sort of reaction to the strictures of Classicism. In July 1746, he wittily claimed

to his friend the politician Henry Fox that he could only write poetry when deep in the English countryside, because 'the trees at Vauxhall [in the pleasure gardens] and purling basins of goldfish never inspire one'. They were somehow not real enough. Later, in the early 1750s, although he commissioned a Chinese pavilion for the garden of Strawberry Hill from his design advisor Richard Bentley, he never actually built it. Walpole particularly came to dislike the strange and nonsensical fashion for fusing Gothic and Chinese styles, West and East – with results which were mocked in *Connoisseur* (1756):

> The trav'ller with amazement sees
> A temple, Gothic or Chinese;
> With many a bell and tawdry rag on,
> And crested with a wooden dragon.

Such a fusion was too much like a fancy-dress ball. Walpole may have collected books about China, but they were lodged in a room which had a chimneypiece based on tombs at Westminster and Canterbury, and shelves with pointed arches based on the choir of old St Paul's.

In other fashionable circles, the craze for anglicized versions of Chinese design continued apace: Chippendale offered a fretback 'Chinese' chair in 1753, while Walpole could stroll from Strawberry Hill to watch the Duke of Cumberland's 'Mandarine Yacht' sail by with dragons down each side, as it cruised along the Thames. In time, the craze would come to be amply serviced by that well-known province of China called Stoke-on-Trent. While Walpole wasn't too sure about this craze, he certainly saw its literary advantages, and seized on a new stock figure in the literary landscape, the Chinese correspondent, as a vehicle for his satires on the eccentricities of English politics. In May 1757, he wrote (in one day) the brief sixpenny pamphlet *A Letter from Xo Ho* [meant to sound like 'Ho Ho'], *A Chinese Philosopher at London to his friend Lien Chi at Peking*, which 'went through five editions in a fortnight', Walpole noted with evident self-satisfaction. The pamphlet begins, 'I have told thee, these people are incomprehensible', and ends with the thought that 'Reason in China is not reason in England'. Confucian rationalism, thinks Xo Ho, is so much more sensible than the factionalism and in-fighting of British politics which has led to the needless court-martial and execution of Admiral Byng. And as for the weather,

> England is not China. Hear, and I will tell thee briefly, the English have no sun, no summer as we have, at least their sun does not scorch like ours. They content themselves with names: at a certain time of the year they leave the capital, and that makes 'summer'; they go out of the city and that makes the 'country'. Although all the courtiers say *'it is hot'*, if thou wilt believe me I am now writing to thee before a fire!

Xo Ho does not know whether or not to trust the newspapers and journals for reliable information:

> Here one is told something every day: the people demand to be told something, no matter what. If a politician, a

minister, a member of their assembly, was mysterious, and refused to impart something to an enquirer, he would make an enemy: if he tells a lie, it is no offence; he is communicative; that is sufficient to a *free* people: all they ask is news; a falsehood is as much news as truth.

A few years later, Oliver Goldsmith took the name 'Lien Chi' for *his* highly educated Confucian Chinese correspondent, in *The Citizen of the World, or Letters from a Chinese Philosopher* (1762). Lien Chi writes to the first president of the ceremonial academy at Peking, Fum-Hoam, about the foibles of the British and above all the mad artificiality of Chinoiserie: 'Sprawling dragons, squatting pagodas, and clumsy mandarines were stuck on every shelf.' In England, adds Lien Chi, they even treat decorated porcelain tubs as works of art for contemplation rather than as 'useful utensils': 'Those, though they may appear fine in your eyes, are but paltry to a Chinese . . . nothing is truly elegant but what unites use with beauty.'

Even after this, in the late 1760s, Horace Walpole could write a nonsense tale called *Mi Li. A Chinese Fairy Tale*, finally published from the Strawberry Hill Press in 1785 in an edition of just seven copies. *Mi Li*, like his other *Hieroglyphic Tales*, was written to amuse a few close friends, and was full of references to them, to their families, houses, estates and possessions. This belated contribution to the mocking of Chinoiserie – and especially of its most recent manifestation,

the aristocratic Chinese garden inspired by the Tory Sir William Chambers – tells of the wanderings of a Chinese prince (Mi Li, pronounced 'My Lie'), who does not recognize any of the English 'Chinese' influences as having the remotest connection with his home culture. However, what keeps him going is that he has had a prophetic dream that he will find his destined wife in a place where – among many other attractions – there will be 'a subterraneous passage in which there are dogs with eyes of rubies and emeralds', and this does indeed, in a highly convoluted way, come to pass. His post-chaise breaks down near Henley, and Mi Li finds himself in the park belonging to General Henry Seymour Conway – Walpole's favourite first cousin, as we have seen – at Park Place, 'when on a sudden they were pursued by several small spaniels, and turning to look at them, the prince perceived their eyes shone like emeralds and rubies'. (Walpole appended an autobiographical note: 'At Park-place there is such a passage cut through a chalk-hill: when dogs are in the middle, the light from the mouth makes their eyes appear in the manner he described'.) This encourages Mi Li to press on 'like one frantic, crying out, "I advance! I advance!"'

Walpole must have purchased his blue-and-white tub before he began to become disillusioned by the willow-patterned world – some time between 1735 (when first he started collecting books about China, and the tub was relatively new) and a decade later. It remained a prized possession to his dying day, but that was for a very different reason.

A FAVOURITE CAT

It was, almost certainly, in February 1747 that Selima the tabby cat drowned in the large porcelain tub. Evidently she liked to perch on its edge, fascinated by the glittering movement of the goldfish within. On the day in question, Selima fell into the tub and was unable to claw her way out up the slippery sides. According to its first illustration, by Richard Bentley, the tub was kept indoors at Arlington Street, on the floor near a large and ornate hinged cabinet (see the detail on p. 20). So Selima did not have to climb very high, and the tub did not topple when she balanced on it. Walpole wrote to Gray – with whom he was by now close friends again, a reconciliation that would, against all the odds, last until Gray's death in 1771 – asking the poet if he would write some sort of epitaph for his late lamented and 'handsome' cat. He was genuinely upset, as he always was by the death of his animals, though the upset did not, as we've seen, tend to last very long. Gray replied from Peterhouse, Cambridge (where he had been a Fellow-Commoner for over ten years), on or around Sunday 22 February, saying that he couldn't begin to grieve properly until he was sure exactly which cat it was and whether or not Selima was the correct name:

> As one ought to be particularly careful to avoid blunders in a compliment of condolence, it would be a sensible satisfaction to me (before I testify my sorrow, and the sincere part I take in your misfortune) to know for certain, who it is I lament. Zara I know and Selima I know (Selima was it, or Fatima?) or rather I knew them both together; for I cannot justly say which was which. Then as to your handsome cat, the name you distinguish

her by, I am no less at a loss, as well knowing one's handsome cat is always the cat one likes best; or, if one be alive and the other dead, it is usually the latter that is the handsomest. Besides, if the point were never so clear, I hope you do not think me so ill-bred or so imprudent as to forfeit all my interest in the survivor: oh no! I would rather seem to mistake, and imagine to be sure it must be the tabby one that had met with this sad accident. Till this affair is a little better determined, you will excuse me if I do not begin to cry: Tempus inane peto, requiem, spatiumque doloris . . .

Gray always tried very hard to compete in wit with his celebrated correspondent, but never quite managed to pull it off. He couldn't resist peppering his letters – as indeed his poems – with abstruse scholarly references and allusions. In a particularly acerbic moment, Walpole was later to write: 'he is the worst company in the world – from a melancholy turn, from living reclusively, and from a little too much dignity, he never converses easily – all his words are measured and chosen, and formed into sentences; his writings are admirable; he himself is not agreeable.'

The 22 February letter about the cat is a case in point. There are the throwaway references to the Acts of the Apostles and to Virgil's *Aeneid*, IV, 433 (Dido's heartbroken exclamation translates as 'I beg for empty time, for peace and reprieve from my frenzy'), and the defensive tone of 'I hope you do not think me so ill-bred': Gray was always hyper-aware (as was Walpole) of his origins as the only child of twelve to survive, born to Philip, a money scrivener and

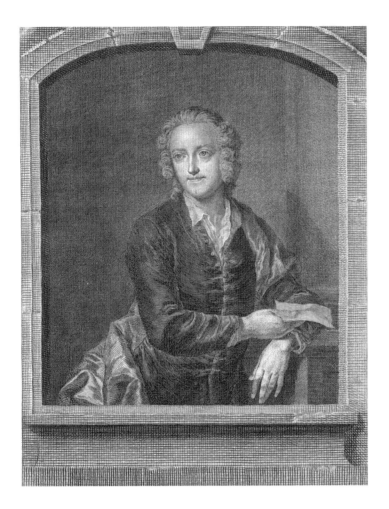

The poet Thomas Gray, after the portrait by
J. G. Eckhardt – painted in 1747, the same year
as the Ode on the Death of a Favourite Cat.
The engraving, by J. S. Muller, was made in 1753
in connection with Bentley's publication of the poem,
but Gray refused to let it be included.

exchange broker in Cornhill, who had the reputation of being half-mad and prone to domestic violence, and the courageous Dorothy, the victim of the violence, who co-owned and ran a milliner's shop with her sister. This was a middle-class, mercantile background, which the gentleman poet sometimes liked to distance himself from, especially when in Walpole's company. Walpole was, after all, the son of the man who had been the most powerful figure in England.

One of the many causes of the row in Reggio – apart from being a kind of lovers' tiff – had been Walpole's aristocratic high-handedness and Gray's sophisticated gaucheries. But by 1747, Walpole had staged a series of elaborate reconciliation tableaux over dinners and breakfasts in Arlington Street. After all, they had known each other as very close friends since Eton days, and Gray was a useful literary foil, just beginning to find his own poetic voice. In the February letter, the over-the-top comparison of Queen Dido's frenzy at her lover's departure from Carthage with sorrow at the death of a cat hinted at the shape of things to come. This was about loss and grandiloquence at the same time.

A week later, on Sunday 1 March, Gray sent a follow-up letter from Cambridge. By then he seems to have learned exactly 'who it is I lament': it was indeed Selima, the tabby. This letter included the first version of a poem which was much, much more than an epitaph. 'Heigh ho!', he wrote, 'I feel (as you to be sure have done long since) that I have very little to say, at least in prose. Somebody will be the better for it; I do not mean you, but your cat, *feue Mademoiselle Selime,* whom I am about to immortalize for one week or fortnight as follows:'

On the Death of a Favourite Cat, Drowned in a Tub of Gold Fishes

I.

'Twas on a lofty vase's side,
Where China's gayest art had dyed
 The azure flowers that blow;
The pensive Selima reclined,
Demurest of the tabby kind,
 Gazed on the lake below.

II.

Her conscious tail her joy declared,
The fair round face, the snowy beard,
 The velvet of her paws,
Her coat that with the tortoise vies,
Her ears of jet, and emerald eyes,
 She saw; and purred applause.

III.

Still had she gazed: but 'midst the tide
Two beauteous forms were seen to glide,
 The genii of the stream:
Their scaly armour's Tyrian hue
Through richest purple to the view
 Betrayed a golden gleam.

IV.

The hapless nymph with wonder saw:
A whisker first and then a claw,
 With many an ardent wish,
She stretched in vain to reach the prize
What female heart can gold despise?
 What cat's a foe to fish?

V.

Presumptuous maid! with looks intent
Again she stretched, again she bent,
 Nor knew the gulf between.
(Malignant fate sat by and smiled.)
The slipp'ry verge her feet beguiled:
 She tumbled headlong in.

VI.

Eight times emerging from the flood
She mewed to ev'ry wat'ry God
 Some speedy aid to send.
No dolphin came, no Nereid stirred
Nor cruel Tom, nor Harry heard.
 What fav'rite has a friend?

VII.

From hence, ye beauties undeceived
Know, one false step is ne'er retrieved,
 And be with caution bold.
Not all, that tempts your wand'ring eyes,
And heedless hearts, is lawful prize:
 Nor all that glisters, gold.

'There's a poem for you,' he concluded: 'it is rather too long for an epitaph.' We don't know the exact version he sent to Walpole – that part of the letter has disappeared. The one printed here is from its very first publication, in 1748, which was based on Gray's earliest version. In a letter on 17 March, to his genial Cambridge friend and Fellow of Pembroke, Thomas Wharton, enclosing a slightly different copy of the poem, Gray wrote: 'the most noble of my Performances latterly is a Pôme on the uncommon Death of Mr W's Cat. w^{ch} being of a proper Size and Subject for a Gentleman in your Condition to peruse . . . I herewith send you. it won't detain you long.'

Give or take a word or two, the poem is what came to be known as Thomas Gray's *Ode on the Death of a Favourite Cat, Drowned in a Tub of Gold Fishes* (also originally called by Gray in the letter to Wharton *On a Favourite Cat, call'd Selima, that fell into a China Tub with Gold-Fishes in it and was drown'd*, and elsewhere *On the Death of Selima, a favourite Cat, who fell into a China Tub with Gold-Fishes in it and was drowned*). In stanza I two lines were transposed; in stanza III 'beauteous forms' became 'angel forms'; 'What cat's a foe to fish?' in stanza IV became the celebrated 'What cat's averse to fish?'; in stanza VI 'What fav'rite has a friend?' became 'A fav'rite has no friend', and 'Harry' became 'Susan'. With these and other slight amendments, Gray's poem – to which Walpole was pleased to give the status of an ode (but then again, as Gray was to point out in August 1752, he called everything of Gray's an ode 'though it be but a receipt to make apple dumplings') – went to press again in 1753 (see pp. 35–37; the version chiefly quoted from now on), and in many authorized and unauthorized editions after that.

The poem was first published (anonymously) on 15 January 1748 by the footman-turned-bookseller Robert Dodsley of Pall Mall, co-publisher of Samuel Johnson's *Dictionary*, as part of a three-volume *Collection of Poems, By Several Hands* – probably because of Walpole's enthusiasm for it, and probably based on the original sent to him rather than on the Wharton version. As part of the reconciliation between them (and perhaps with a measure of guilty conscience as well) Walpole made every effort to champion Gray's work, even to the point, eventually, of printing nearly all his poems himself at the Strawberry Hill Press. After the Dodsley publication was issued, he immediately wrote to the poet to ask how it had been received by the Cambridge set. Gray replied, with his usual hint of defensiveness: 'As to what one says since it came out, our people (you must know) are slow of judgement; they wait till some bold body saves them the trouble, then follow his opinion; or stay till they hear what is said in town, that is at some bishop's table or some coffee-house.'

The *Ode* also circulated in manuscript, in various versions, and others were much less slow in judgment. Soon there appeared another poem, which parodied Gray's title: this was *A Sorrowful Ditty; Or, the Lady's Lamentation for the Death of her Favourite Cat. A Parody*, attributed by some to the novelist, historian and wit Tobias Smollett, whose nautical novel *Roderick Random* had recently been published. *A Sorrowful Ditty* burlesqued, in questionable taste, a famous *Monody To the Memory of a Lady Lately Deceased* which had been written in December 1747 by the Hon. George Lyttleton on the death of his wife, which in turn led to a confusion between the *Ditty* and the *Ode* and to the allegation that it was Gray who had

burlesqued the *Monody*. In fact he hadn't, and Walpole took the trouble to refute the allegation. The first time Gray saw the *Monody* was in May 1747: the confusion was compounded when Dodsley published both *Ode* and *Monody* in his 1748 *Collection of Poems*. But the parody title shows how well known Gray's *Ode* was already becoming in authorized and unauthorized forms. In 1755, it appeared in a popular anthology, Mary Masters' *Familiar Letters and Poems on Several Occasions* (in a version with several misprints, claiming 'Mr De Grey' as its author), followed by two new sequels: one was a poem written by a lady to Selima's human mistress (!), and the other was about whether Phoebus should have come from the skies to Selima's rescue. It is clear that the poem appealed well beyond Gray's usual circle. What particular social occasion Mary Masters may have had in mind – a cat's funeral? – is not clear.

And yet the *Ode* is very much in the same spirit as Gray's earlier odes, albeit in a more witty and urban rather than pastoral vein. It is about loss and mourning, Fate and Destiny – big subjects insulated as usual from the real world by reassuring references to other poets. The *Ode* is a mosaic of consolatory poetic allusions including, probably, Pope's Helen of Troy ('the brightest of the female kind') on the battlements, from his translation of *The Iliad*; Milton's Eve admiring herself in the smooth lake from *Paradise Lost*; the death of Camilla in Virgil's *Aeneid*; a Catullus song; Dryden's satire *The Hind and the Panther* ('fairest creatures of the spotted kind') and his *Alexander's Feast* (''Twas at the Royal Feast'), which may also have suggested the metrical form of the verse; plus maybe Ovid's *Ars Amandi* and *Metamorphoses* and Pope's

The Rape of the Lock – ancient *and* contemporary allusions which the poet would have expected the cultivated reader, in the first instance Walpole, to recognize and enjoy, as an affirmation of a particular culture and a tradition. At a slightly more popular level – though still with Tom the footman and Susan the maidservant in attendance – there are references to John Gay's translated verse *Fables* and his social satire *Toilette*, to the well-known story of Arion being rescued from the sea on the back of a dolphin, and to the fable by Aesop in which Venus changes a much-loved cat into a woman, for the benefit of the young man who dotes on her.

There are the careful and clever uses of words: 'tub' in the title and 'vase' in the first line; 'demurest', which in Johnson's *Dictionary* is exemplified under 'demure' and 'demurely' with quotations from Bacon and Dryden concerning Aesop's cats, and which from now on would become even more closely linked in the language with cats (for example, in the opening chapter of *Alice Through the Looking-Glass*, where 'Kitty sat very demurely on her knee'); and 'tabby', henceforth to be indelibly associated with cats. And there is the long description of goldfishes, which was necessary because they were still a relatively unusual, even rarefied, luxury good.

Above all, in this small masterpiece about a cat named after a princess, there is the sprightly tone: a mixture of mock-epic, mock-heroic, mock-ballad, mock-lament, mock-animal-fable, mock-morality-tale about women, all presented in a knowing way to memorialize the sad death of Walpole's cat. Gray could have written in heroic couplets: instead he chose – maybe deliberately – the verse form known as tailed rhyme: lines three

and six contain rhyme, tailing after one and two, four and five. Her conscious tail her joy declared. This is about Gray's affection for Walpole; his rejoining of the club after his membership had been lapsed; a poem written to order at Walpole's request, intended to show off the poet's versatility. With the *Ode*, Gray reaches out to his boyhood friend and hero. Their mutual affection at Eton had been very intense, although the Grand Tour had nearly scuppered it, and Gray took a long time to recover.

The poem raises the curtain by putting this small domestic upset into a pumped-up classical perspective: the waters become a lake, the cat a nymph and the fish the 'genii of the stream'. From then on, Gray cleverly juggles commonplace sayings and stereotypical reactions – 'What female heart can gold despise?'; 'Presumptuous maid!'; 'From hence, ye beauties, undeceived'; 'Nor all that glisters, gold'; a cat has nine lives; curiosity killed the cat – with a web of classical and poetic allusions to distance the reader from the facts and console him or her. But the facts are there in the form of closely observed detail.

> Demurest of the tabby kind,
> The pensive Selima reclin'd,
> Gazed on the lake below.
>
> Her conscious tail her joy declar'd;
> The fair round face, the snowy beard,
> The velvet of her paws,
> Her coat, that with the tortoise vies,
> Her ears of jet, and emerald eyes,
> She saw; and purr'd applause.

Gray certainly knew his cats. Whether he was as fond of dogs is a moot point. When he was still an undergraduate, he had written of a visit to his uncle in the country, where the hunting dogs, inactive because the uncle had gout, were curled up on every chair so that Gray was forced to resort to the mantelpiece as his writing desk. The uncle liked to keep the dogs around him 'to regale his Ears and Nose with their comfortable Noise and Stink'. Gray much preferred walking and meditating to the usual country pursuits. But he knew his cats. And he knew from his recent visits to Arlington Street about the goldfish too: the lofty vase, decorated with China's gayest art. He knew that the fish were not swimming around in a clear glass bowl but in a solid porcelain one with a transparent glaze which created a reflecting surface (the cat gazing at her image: p. 20) and when viewed from above also distorted the true colours of the fish:

> Their scaly armour's Tyrian hue
> Thro' richest purple to the view
> Betray'd a golden gleam.

The fish *seem* purple – the colour of a Roman dignitary's toga – but they are really golden. Appearances are deceptive. And the moment of the cat's death has been called one of the most unfeeling, or at least chilling, pieces of clever writing ever committed to paper:

> The slipp'ry verge her feet beguil'd,
> She tumbled headlong in.
>
> Eight times emerging from the flood
> She mew'd to ev'ry watry God . . .

Gray could be a realist when he wanted to.

◆◆◆◆◆◆◆◆◆◆◆◆◆◆◆◆◆◆◆◆◆◆

THE FIRST DESIGNS: RICHARD BENTLEY (1751–52)

In the European visual arts, cats were beginning to be painted at around this time as 'pets' – design accessories to humans, almost always females or children – rather than as predators, hangers-on in public places or mousers in the kitchen. They appeared on laps, in arms, on bed covers and buffeting dainty feet. Cats had also moved into the Rococo boudoir, a powdered setting which associated them with eroticism, sensuality and sometimes malice. The idea of the 'sex kitten' seems to have its distant origins in the mid-eighteenth century. Especially in France. Think of François Boucher's women at their cluttered dressing tables, or adjusting their frilly garters, with their Chinese screens and their cats playing at their feet. Or Jean-Honoré Fragonard's cats silently witnessing an elaborate and illicit *fête galante*. Jean-Baptiste Chardin preferred to stand *his* cat, nervous and hungry, on a pile of oysters – in a painting, *The Ray*, which Proust and later Picasso much admired. Where the decorative arts were concerned, the fashion in Britain for ewers, cups and vases with handles in the shape of lions or panthers standing on their hind legs – for example, in designs by Robert Adam, or Wedgwood and Bentley, or in bronze casts of Louis XIV pieces – was based on Roman originals, as mediated through engravings of the sixteenth and seventeenth centuries. Such big cats on handles often featured as props in the paintings of Boucher and Chardin. Sometimes, in the engravings which inspired the British designers, the cats are standing, sometimes drinking. Eventually the idea would become adapted, domesticated and mass-produced as ceramic jugs in the shape of milk churns with handles in the form of a cat climbing up the churn to steal the milk. But that wouldn't happen until the nineteenth century. In the paintings of Walpole's time, the practical cat was making way for the sensual or wanton cat. Selima – with 'Her ears of jet, and emerald eyes', her purring, her likeness to a 'hapless nymph', her status as a 'fav'rite' and her beauty – belongs, in her demure and refined way, to these emerging traditions. Selima is not a practical cat. She is Walpole's pet and she knows it.

The Romantic poets found the *Ode* too clever-clever. They were put off by the wilful obscurity. Victorian critics found the shifts of tone – from tragedy to comedy, from classical allusions to a cat falling into a bowl – unsettling and muddling. Literary critics in the mid-twentieth century on the one hand much enjoyed arguing about the web of Augustan allusions (and the melancholia) of Gray's poems, and especially his *Ode*. Milton, Dryden and Pope were meat and drink to them. 'Practical criticism' was the way to take a poem apart. Did Gray's readers in the mid-eighteenth century recognize and understand the allusions? Was this another case of the world we have lost?

More recently, with the post-modernist interest in the politics of gender and identity, other meanings have been found in the *Ode*. It has been argued that hidden within the poem is a riff on John Locke's description of the human mind trying to understand itself – getting beyond the world of external appearances: a study in perception. It has also been argued that Gray's poem is full of puns – some of them bawdy – all deliberately based on out-of-date meanings of

words: thus tabby = silk/woman in a dress; lake = a lewd play, hence the 'applause'; tail = a fashionable hairstyle; paws = something vulgar; tortoise = hairbrush; jet = of fashion; 'Tyrian' suggests tyne = a skin disease; verge = penis; nymph = vagina; flood = menstrual bleeding; favourite = a coquettish curl of the hair. If all these archaic meanings (as given in the *Oxford English Dictionary*) were indeed known to Gray, and if with his very precise use of language he was aware of their cumulative effect, then the *Ode* is also a kind of 'whore's progress': a woman visits a lewd play, and her own life is mirrored in the action on the stage. Maybe this was a level of meaning – part of the sub-culture of pornographic literature, to use an anachronistic term – which Gray and Walpole could secretly share. It would certainly have been clear to eighteenth-century readers that the *Ode* was in part a burlesque of morality tales about women: to give way to desires of the flesh is a form of 'presumption'. The most recent interpretation takes that idea one step further, by making more explicit the double meanings. So it could have been subtitled *Mogg Flanders*, perhaps, or *Tabby Hill*. This certainly goes with the idea of a cat as sensual, sexy creature. Sometimes, a misogynist idea.

But whether or not this was intentional, it was *Designs by Mr. R. Bentley for Six Poems by Mr. T. Gray*, a folio volume with six plates and vignettes issued by Dodsley in March 1753, that turned Gray's poem into a publishing phenomenon as one of the most important illustrated books of the age. It was the first time a collection of poems had been published under Gray's name, and six further editions followed. As the scholar

Loftus Jestin has written, 'The designs represented a giant leap forward in the art of book illustration and were not sur-passed until William Blake's work in the 1780s.'

Horace Walpole had met Richard Bentley (1708–82), the wayward and artistically talented only son of the Master of Trinity College, Cambridge, in the late 1740s. By summer 1750, he was referring to young Richard as the friend 'whom I adore', inviting him to become an architectural advisor on Strawberry Hill as one of the three-man 'Committee on Taste', and encouraging him to live in Teddington, as close as possible to the Gothic villa. A year later, Bentley had become 'our charming Mr. Bentley'. The two men evidently had a riotous time together concocting the illustrations to Gray's poems at Strawberry Hill between June 1751 and June 1752 and egging each other on. Walpole had such a good time that the experience encouraged him to set up his own private press some four years later.

It has been justly said of Bentley that he was a child genius who never threw off either the child or the genius. Certainly, his father (Richard senior), a very eminent scholar lacking the requisite sense of humour or of the ridiculous, was not at all amused ('Tully did have his Marcus', he would sometimes be heard to sigh – a reference to Marcus Tullius Cicero, whose son with exactly the same names, like young Richard, exas-perated his famous father, before defending his reputation after Cicero's death) and eventually disinherited him.

Somehow, Bentley's artistic talent survived both his academic upbringing and his badly behaved adolescence. Where Walpole was concerned, Bentley had 'more taste and

more misfortune than sure I ever met in anyone'. He even compared him favourably with Poussin.

Each of Gray's *Odes* would have a frontispiece, a head-piece, an initial letter and a tailpiece. In the cat poem, these would mirror the mock-serious quality of the words. The engravings (by Charles Grignion, after Bentley's very detailed designs) would look like established works of art from Italy or France, but on closer inspection would prove to be playful, witty, teasing (sometimes at Gray's own expense), part-Gothic, part-Rococo, developing through pictures the themes of the poems rather than just providing pretty embellishments to them. They would complete the text, *and* compete with it. They would also be incorporated into it. And the layout would be suitably spacious for readers to enjoy the fun (the illustrations on pp. 34–37 give an idea of the size). So, for the *Ode on the Death of a Favourite Cat*, there would be, combined in the various images, cats as mourners in black hatbands and scarves; provocative mice – one with a clyster-pipe or enema; 'some mandarin-cats fishing for gold-fish' (which Walpole in a letter of 6 June 1752 thought a particular delight); Destiny cutting the nine threads of the cat's life; a grotto; and a boat ferrying the deceased tabby cat across the Styx, with Selima's fur standing up on end as she spits at the sight of Cerberus, the multi-headed dog. There would also be details of the bowl, its location and its reflection of the sash-window panes as light source. Irene Tayler has written that this household cat was now surrounded in mock solemnity by the rich culture of a mid-eighteenth-century connoisseur.

But while Walpole smiled, Gray became more and more alarmed – as his letters show. At first, he was uncharacteristically relaxed about the project. Then he threw 'cold water' over some of Bentley's ideas. Then he was worried about whether the format was the right one for him. Then he wanted his engraved portrait – see p. 25 – removed ('if you suffer my Head to be printed, you infallibly will put me out of mine'). Then he was worried about Walpole's proposed 'explanations' of the drawings – see p. 38 – (for the use, presumably, of 'people that have no eyes'). He didn't like 'explanations' of his poems, so why for the pictures? Finally he insisted that instead of being issued as a collection of poems by Thomas Gray the book should be retitled *Designs by Mr. R. Bentley for Six Poems of Mr. T. Gray*. By February 1753, the poet had worked himself up into quite a state about all this, and wrote to Dodsley:

> I am not at all satisfied with the Title. to have it conceived, that I publish a Collection of *Poems* (half a dozen little Matters, four of w^ch too have already been printed again and again) thus pompously adorned would make me appear very justly ridiculous. I desire it may be understood (w^ch is the truth) that the Verses are only subordinate, and explanatory to the Drawings, and suffer'd by me to come out thus only for that reason. therefore if you yourself prefix'd this Title, I desire it may be alter'd; or if Mr W: ordered it so, that you would tell him, why I wish it were changed . . . for the more I consider it, the less I can bear it, as it now stands.

✦✦✦✦✦✦✦✦✦✦✦✦✦✦✦✦✦✦✦✦✦✦✦✦

I even think, there is an uncommon sort of Simplicity, that looks like affectation, in putting our plain Christian & Surnames without a M^r before them; but this (if it signifies any thing) I easily give up; the other I can not. you need not apprehend, that this Change in the Title will be any prejudice to the Sale of the book . . . perhaps you may have burnt my [last] Letter, so I will again put down the Title

> Designs by M^r R. Bentley
> for six Poems of
> M^r T. Gray

With the alteration of 'by' for 'of', this was the final and strange title of the book.

Walpole, who was the midwife of the publication, was prepared to go along with Gray in an unusually long-suffering way, but was by no means convinced. As he wrote from Arlington Street on 20 February 1753,

> The Head I give up. The Title I think will be wrong, and not answer your purpose, for, as the Drawings are evidently calculated for the poems, why will the improper disposition of the word *Designs* before *Poems*, make the Edition less yours? I am as little convinced that there is any affectation in leaving out the *Mr* before your Names; it is a barbarous addition; the other is simple and classic, a rank I cannot help thinking due to both the Poet and Painter . . . The Explanation was

certainly added for people who have not Eyes – such are almost all who have seen Mr Bentley's drawings, and think to compliment him by mistaking them for prints. Alas! the generality want as much to have the words *a Man, a Cock*, written under his drawings, as under the most execrable hiero-glyphics of Egypt or of sign post painters! I will say no more now . . . dont suspect me when I have no fault but impatience to make you easy.

Both Bentley and Gray left poetic evidence of how they viewed, in retrospect, the experience of working together. On a visit to Strawberry Hill in August 1757 – over four years later – while he was waiting for Walpole to return from town, Bentley arranged for a sonnet about Gray to be set up on the printing press:

> Ah! When perform'd thy very best,
> Small good is brought to pass;
> Writers and Readers are increased,
> But Judgment's where it was . . .
>
> . . . Congenial Souls their scepter own:
> Gray waits for Sense's reign.
>
> Truly to benefit Mankind
> I fear exceeds thy art;
> Thou canst not stamp upon the mind
> Nor print upon the heart.

A FAVOURITE HAS NO FRIENDS

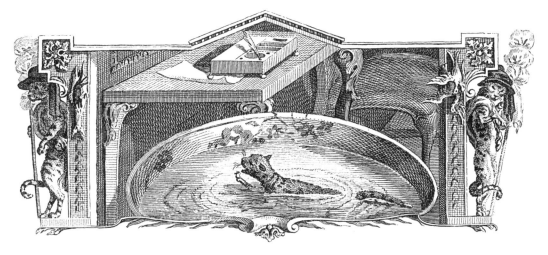

O D E

On the Death of a Favourite C A T,

Drowned in a Tub of Gold Fiſhes.

'T WAS on a lofty vaſe's ſide,
Where China's gayeſt art had dy'd
 The azure flowers, that blow;
Demureſt of the tabby kind,
The penſive Selima reclin'd,
 Gazed on the lake below.

Her conſcious tail her joy declar'd;
The fair round face, the ſnowy beard,
 The velvet of her paws,
Her coat, that with the tortoiſe vies,
Her ears of jet, and emerald eyes,
 She ſaw; and purr'd applauſe.

 Still

Still had fhe gaz'd : but 'midft the tide
Two angel forms were feen to glide,
 The Genii of the ftream :
Their fcaly armour's Tyrian hue
Thro' richeft purple to the view
 Betray'd a golden gleam.

The haplefs Nymph with wonder faw :
A whifker firft and then a claw,
 With many an ardent wifh,
She ftretch'd in vain to reach the prize.
What female heart can gold defpife ?
 What Cat's averfe to fifh ?

Prefumptuous Maid ! with looks intent
Again fhe ftretch'd, again fhe bent,
 Nor knew the gulf between.
(Malignant Fate fat by, and fmil'd)
The flipp'ry verge her feet beguil'd,
 She tumbled headlong in.

Eight times emerging from the flood
She mew'd to ev'ry watry God,
 Some fpeedy aid to fend.

 No

No Dolphin came, no Nereid ſtirr'd :
Nor cruel *Tom*, or *Suſan* heard.
 A Fav'rite has no friend !

From hence, ye Beauties, undeceiv'd,
Know, one falſe ſtep is ne'er retriev'd,
 And be with caution bold.
Not all that tempts your wand'ring eyes
And heedleſs hearts, is lawful prize ;
 Nor all, that gliſters, gold.

EXPLANATION of the PRINTS.

ODE on the Death of a Favourite CAT.

FRONTISPIECE.

THE cat ſtanding on the brim of the tub, and endeavouring to catch a gold fiſh. Two cariatides of a river god ſtopping his ears to her cries, and Deſtiny cutting the nine threads of life, are on each ſide. Above, is a cat's head between two expiring lamps, and over that, two mouſe-traps, between a mandarin-cat ſitting before a Chineſe pagoda, and angling for gold fiſh into a china jar ; and another cat drawing up a net. At the bottom are mice enjoying themſelves on the proſpect of the cat's death ; a lyre and pallet.

HEADPIECE.] The cat almoſt drowned in the tub. A ſtandiſh on a table to write her elegy. Two cats as mourners with hatbands and ſtaves. Dead birds, mice and fiſh hung up on each ſide.

INITIAL LETTER.] The cat, demureſt of the tabby kind, dozing in an elbow chair.

TAILPIECE.] Charon ferrying over the ghoſt of the deceaſed cat, who ſets up her back on ſeeing Cerberus on the ſhore.

In Bentley's view, then, Gray certainly *did* require 'explanations': the reading public even at the time found him difficult. Where Gray was concerned, when first he saw the proofs of the engraved versions of Bentley's drawings, somewhat to his surprise he was very impressed by the quality of the work. Then he wrote some suitably hyped-up stanzas addressed to Bentley which may originally have been intended as a preface to the book:

> In silent gaze the tuneful choir among,
> Half pleased, half blushing, let the
> Muse admire,
> While Bentley leads her sister-art along,
> And bids the pencil answer to the lyre.
> See first their course, each transitory thought
> Fixed by his touch a lasting essence take;
> Each dream, in fancy's airy colouring wrought,
> To local symmetry and life awake!

> The tardy rhymes that used to linger on,
> To censure cold and negligent of fame,
> In swifter measures animated run,
> And catch a lustre from his genuine flame,
> Ah! Could they catch his strength, his
> easy grace,
> His quick creation, his unerring line;
> The energy of Pope they might efface,
> And Dryden's harmony submit to mine.

When these unfinished 'stanzas' were first published in 1775, over twenty years after the book they were probably meant to preface, some critics didn't know whether to take them seriously or not. Bentley's designs were good, but not *that* good. Surely the praise was excessive? Walpole sent a copy of Gray's *Odes* to Arthur Onslow at Ember Court – remember him from *Patapan*? – in August 1757. History does not record Onslow's reaction to the gift.

THIS LOFTY VASE

Certainly, in the end, Thomas Gray's reticence and scholarship, Horace Walpole's exuberance and wit, and Richard Bentley's strong streak of anarchy combined with his untutored vivid style had resulted in a classic publication – which, very popular though it was in the latter part of the eighteenth century, has never been reprinted since 1787. The Victorians didn't get the joke. Matthew Arnold called Gray's work 'the scantiest and frailest of classics in our poetry'. The twentieth century has been much kinder. Sir Kenneth Clark, no less, called Bentley's designs 'the most graceful monument to the Gothic Rococo' and added of his contribution in general that 'Bentley employed Gothic because its name licensed any extravagant invention'. The book came to be treated as one of the jewels in the crown of the Augustan age. But there was still no reprint.

Samuel Johnson did not get the joke either, even though he was a cat person by temperament. In his last major work, *The Lives of the Most Eminent English Poets*, when in volume four he reached the poets whose lifetimes coincided with his own, he tended to let his attitude towards the living person cloud his attitude towards the work. In the case of Gray, he disapproved of the shy, finicky, hypochondriac, ill-at-ease bachelor don who in his view 'cultivated his mind and enlarged his views without any other purpose than of improving and amusing himself', and who was well known for five poems at most. And this carried over into his comments on the poems, which – with the honourable exception of Gray's *Elegy* – were treated as a matter of fad or fashion promoted by a coterie of friends who pretended to admire his 'glittering accumulation of ungraceful ornaments' because it made them seem clever and gave the poems a dignity they did not deserve. The fact that Horace Walpole was a leading member of this coterie did not help either: when Johnson first arrived in London in the 1730s he had been an outspoken critic of Robert Walpole and Horace had never quite forgiven him for that, as we have seen. Antipathy to the Walpole set helps explain the intensity of his reaction to Gray, whom he'd never met. Gray, in his turn, referred to Johnson on catching sight of him in the street as 'the great bear': 'There goes Ursa Major!' Johnson's position was 'What signifies so much knowledge, when it produced so little?' He memorably described in the mid-1770s Gray's *Odes* as 'forced plants, raised in a hot-bed, and they are poor plants; they are but cucumbers after all'. So when it came to commenting on 'the poem on the *Cat*', the great bear's prejudices tended to be worn on his sleeve. Of the *Designs* publication, he wrote: 'that they might in some form or other make a book, only one side of each leaf was printed'. And of the poem:

> The poem on the *Cat* was doubtless by its author considered as a trifle, but it is not a happy trifle. In the first stanza *the azure flowers* that *blow*, shew resolutely a rhyme is sometimes made when it cannot easily be found. *Selima*, the *Cat*, is called a nymph, with some violence both to language and sense; but there is good use made of it when it is done; for of the two lines,
>
> > What female heart can gold despise?
> > What cat's averse to fish?

the first relates merely to the nymph, and the second only to the cat. The sixth stanza contains a melancholy truth, that *a favourite has no friend*; but the last ends in a pointed sentence of no relation to the purpose; if what *glistered* had been *gold*, the cat would not have gone into the water; and, if she had, would not less have been drowned.

This stern judgment – which is almost as well-known as Gray's poem – is surprisingly literal rather than literary. It misses the mock-heroic quality of the poem, and the deliberate parallel between cat and human being. It misses the references to animal fables, with their 'morals' which involve the author standing outside the story ('From hence, ye beauties, undeceived . . .'). And, above all, perhaps wilfully it does not get the joke. Samuel Johnson could as everyone knew be very grumpy at times. Mrs Elizabeth Montagu, queen of the Blue Stockings, who had already 'dropped' Dr Johnson from her acquaintance, thought he had gone much too far this time. Johnson was likened by her to 'the vampire, who violates the tomb, profanes the sepulchre and sucks the blood of sleeping men'. And several pamphlets rushed to Gray's defence in 1781–83. Boswell had a much higher opinion than the great bear of the Cambridge poet. In the late eighteenth century, Johnson's comments proved influential with some critics, for whom the line between allusion and borrowing was a narrow one – and who favoured less mediated, less detached, forms of expression. Wordsworth famously wrote of Gray, in the Preface to the second edition of the *Lyrical Ballads,* that he was 'more than any other man curiously elaborate in the structure of his own poetic diction'. Gray tended, in Wordsworth's view, to 'speak to the intellect alone'. Coleridge called most of Gray's lyrics 'frigid and artificial'. Hazlitt described the *Odes* as 'stately and pedantic', a sort of 'methodical borrowing phrenzy'; they were 'I believe generally given up at present'.

Whatever Johnson's views, which did cause quite a stir at the time, for Walpole the *Ode* was among his all-time favourites. In 1773, two years after Gray's death at Cambridge, he ordered to be made a Gothic pedestal – resembling a font in a church – on which to place the original blue and white Chinese porcelain tub 'in which my cat was drowned'. It would at first be located in the Great Cloister at Strawberry Hill, then, to make way for a large Piranesi vase (although Walpole didn't in fact know it was by Piranesi), moved to ceremonial pride of place in the Little Cloister. Walpole's own catalogue, *A Description of the Villa of Horace Walpole . . . at Strawberry Hill near Twickenham,* explained the full significance of this move. Visitors would enter Strawberry Hill from the road through the 'great north gate', then walk down a paved way to the main entrance – with its studded Gothic doorway designed by Richard Bentley and built in 1753. Down one side of the paved way was 'a small cloyster by the entrance to the house':

In this cloyster . . . on a pedestal stands the large blue
and white China tub in which Mr Walpole's Cat was
drowned; on a label on the pedestal [printed by Walpole

in 1773] is written the first stanza of Mr Gray's beautiful Ode on that occasion:

> 'Twas on this lofty Vase's Side,
> Where China's gayest Art has dy'd
> The azure Flowers, that blow;
> Demurest of the tabby Kind,
> The pensive Selima reclin'd,
> Gaz'd on the Lake below. &c. GRAY.

As Walpole had written to William Mason in July 1773, the first stanza of the *Ode* would be changed just this once to "Twas on *this* lofty Vase's side, etc.' The blue-and-white tub would be one of the most prominently displayed *objets d'art* that visitors would encounter in the lobby, to the right of the entrance to the house: it was also clearly visible from the entrance hall, through Bentley's doorway. Walpole had a vast collection of ceramics and sculptures, but for many who wrote about Strawberry Hill this was the one. Much, much more interesting than the small marble sculpture of *Two Kittens* by Anne Seymour Damer, dating from 1789, which was later to be hidden away in the Green Closet. By the same token, although Walpole had had many other cats in his life – with names such as Ponto, Selia, Sophy, Fanny, Harold, Mufti, Fatima and of course Zama or Zara – it was Selima who remained in his mind, longer than all his apostolic succession of other deceased animals. And all because of her unfortunate accidental death in a tub of goldfishes, and the poem that followed.

Horace Walpole's goldfish tub, proudly displayed – with caption – on a Gothic pedestal in the Little Cloister at Strawberry Hill, 1784. We are looking from the entrance hall, with Bentley's studded Gothic doorway on the left. (For the tub in colour, and the caption, see p. 65.)

Gray probably thought of the poem as primarily for private consumption, written to amuse and impress a couple of close friends. Its conclusion – 'And be with caution bold' – certainly chimed with his own cautious approach to life with its 'Malignant fate', but beyond that he must have been surprised and probably pleased at its success. Today, it is considered the finest animal fable, the most celebrated poem about cats, and one of the best-loved short poems about anything in the English language. Of its seven stanzas, selections from four have entered the standard repertoire of the dictionaries of quotations:

> Demurest of the tabby kind,
> The pensive Selima reclined

> What female heart can gold despise?
> What cat's averse to fish?

> A favourite has no friend!

> Not all that tempts your wandering eyes

> Nor all that glisters gold.

But it is in Cambridge that the *Ode* has left its most stylish living legacy. Although Gray was a Fellow of Peterhouse when he wrote it, he moved in 1756 to Pembroke College, where he remained until his death. And to this day the Pembroke College cat is often – though not invariably – called 'Thomas Gray', or some variation on the name. The last feline to be named after Gray, according to the published records, was called Thomasina. That was in the mid-1990s. Thomasina was so highly regarded in academic circles that the Professor of Arabic dedicated his translation of Aristotle's *Rhetoric* to her. High praise indeed. (Thomasina's sister, also an official feline Fellow of Pembroke, went by the more prosaic name of Sox, so the onomastic principle is not set in stone. The present feline Fellow of Pembroke is called Kit Smart, after another of our eminent poets who was an undergraduate and Fellow in the 1740s at the same time as Gray: we shall meet him again.) As Mary Archer has written, in words which some might find controversial, 'No animal so dimly acquiescent, so unconditionally slavish as a dog would feel at home in the academic courts of Cambridge, but cats – watchful, self-contained, inscrutable cats – are their natural companions.'

On that, at least, Dr Johnson and Thomas Gray, and maybe even Horace Walpole, would surely have agreed.

TAILPIECE

When the twenty-four-year-old James Boswell visited the fugitive philosopher Jean-Jacques Rousseau at his run-down refuge in the 'wild retreat' of Môtiers above Lake Neuchâtel, Switzerland, at the beginning of December 1764, one of the many topics they talked about was cats. The naïve and hero-worshipping Boswell was on an improvised Grand Tour – without the expense of a tutor – and he'd already dropped in on Rousseau three times on 3–5 December. They had talked about religion, morality and sex, and education. Then on 14 December he had made yet another visit, at the end of which Rousseau advised Boswell to 'put your watch on the table'. The pestering was beginning to get on his nerves, which were already strung to breaking point. Yet somehow Boswell managed to wangle an invitation to 'a simple meal' on 15 December – six dishes, not including dessert – and it was after this that Rousseau raised the subject of cats.

The title-page of the first edition of Rousseau's outspoken *Discourse on the Origin of Inequality* (1755) had featured prominently a female personification of Liberty, reclining in a rustic glade with a contented sleeping cat curled up beside her. Six years later, the title-page of *On the Social Contract* (1762) had featured another, similar, figure of Liberty, this time sitting in a more formal setting on a raised chair surrounded by classical pillars. Next to her was a cat, standing up, alert, with its tail upright in the shape of a question-mark. In the design guide written by Charles-Nicolas Cochin and Hubert-François Bourguignon, called Gravelot – Rousseau's two best-known French engravers – under the word 'CAT' it said this: 'The cat, enemy of all constraint, is useful for characterising liberty.'

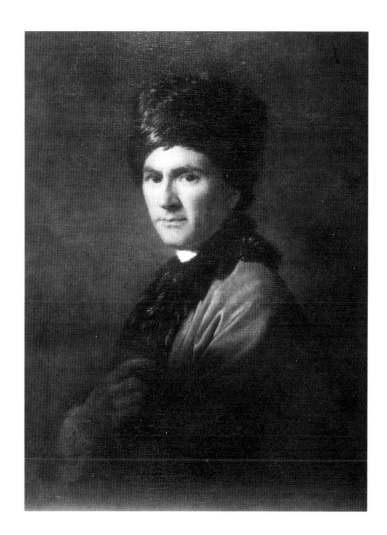

James Boswell, looking somewhat stiff and ill at ease, in an engraving after a drawing by George Langton, published much later, in 1835.

opposite *Title page of Jean-Jacques Rousseau's* Discourse on the Origin of Inequality *(1755), showing the figure of Liberty with her sleeping cat.*

Jean-Jacques Rousseau in his celebrated 'Armenian costume' with fur cap and purple gown: detail of the portrait by the Scottish artist Allan Ramsay, painted early in 1766 when Rousseau was in London.

When *Inequality* was first published, Rousseau was worried that the cat used in this way might even have become too much of a visual cliché: 'The symbols which surround the figure of Liberty are commonplace ones', he wrote to his editor. But Boswell and Rousseau talked after supper about this very theme of constraint and liberty. Rousseau's view – he said to the Scotsman – was that you could tell a lot about people from their attitude to cats. His tone would appear, even in Boswell's version, to have been one of condescending irony. His starting-point was that cats were born free and no way would they ever agree to be in chains.

The conversation went like this, according to Boswell's *Journals*:

ROUSSEAU: 'Do you like cats?'
BOSWELL: 'No.'
ROUSSEAU: 'I was sure of that. It is my test of character. There you have the despotic instinct of men. They do not like cats because the cat is free and will never consent to become a slave. He will do nothing to your order, as the other animals do.'
BOSWELL: 'Nor a hen neither.'
ROUSSEAU: 'A hen would obey your orders if you could make her understand them. But a cat will understand you perfectly and not obey them.'
BOSWELL: 'But a cat is ungrateful and treacherous.'
ROUSSEAU: 'No. That's all untrue. A cat is an animal that can be very much attached to you; he will do anything you please out of friendship. I have a cat here. He has

been brought up with my dog; they play together. The cat will give the dog a blow with his tail, and the dog will offer him his paw.'

Rousseau then, according to Boswell, described the behaviour of his dog and cat 'with exquisite eloquence, as a fine painter draws a small piece'. He had recently expressed his views on cats and freedom, in print, at the end of Book II of his controversial treatise on education, *Emile* – the book which, proudly presented under his own name rather than a pseudonym, caused Rousseau to be constantly on the run from the Parisian, Dutch, Genevan and Bernese authorities, and in particular from the religious establishment, from June 1762 onwards. In a celebrated passage of *Emile*, he likened a young child finding out about the world beyond himself to a cat:

The lessons pupils receive from one another in the playground are a hundred times more useful to them than everything they will ever be told in class. Look at a cat entering a room for the first time. He inspects everything, he looks around, he sniffs, he does not relax for a moment, he trusts nothing before he has examined everything, before he has come to know everything. This is just what is done by a child who is beginning to walk and who is entering, so to speak, the room of the world . . .

Boswell was not so sure. He had, as we have seen, 'an antipathy to a cat, so I am uneasy when in the room with one'. Samuel Johnson had very strong opinions about Rousseau, and what

he saw as the Genevan's pernicious influence on his readers. He discussed them, during a famously startling outburst when Boswell bought up the subject on 16 February 1766. 'It seems to me you have kept very good company abroad . . . If you would be serious I think him one of the worst of men, a Rascal who ought to be hunted out of Society, as he has been . . . Rousseau, Sir, is a very bad man. I would sooner sign a sentence for his transportation than for that of any felon who has gone from the Old Bailey these many years.' It was one thing to talk nonsense without realizing it; most people did that all the time. It was quite another to talk nonsense *and be aware of it*, and then to 'laugh at the world for staring'. Rousseau, concluded Johnson, fell into the latter category. Johnson's outspokenness may have had something to do with jealousy. Boswell was still – just – under Rousseau's spell. But on the question of cats – and possibly on the question of cats alone – Johnson would have agreed with Rousseau. In his *Dictionary*, as well as describing the cat as 'the lowest order of the leonine species', a creature with the heart of a lion, Johnson included many other quotations (often from memory: he must have had an excellent stock of cat quotes) which showed where his sympathies really lay. Whether the cat was a practical cat, a mouser, or a pet in league with Venus, Samuel Johnson had evidently watched the creature at very close quarters. His many related definitions have been collected in *Hodge and Other Cats*.

CREAM. The unctuous or oily part of milk, which, when it is cold, floats on the top, and is changed by the agitation of the churn into butter; the flower of milk.

I am as vigilant as a cat to steal *cream.*
> *Shakesp. Henry IV*

DEMURE. Grave; affectedly modest: It is now generally taken in a sense of contempt.

A company of mice, peeping out of their holes, spied a cat, that lay and looked so *demure* as if there had been neither life nor soul in her.
> *L'Estrange*

FROLICK. A wild prank, a flight of whim and levity.

While rain depends, the pensive cat gives o'er
Her *frolicks*, and pursues her tail no more.
> *Swift*

KITTEN. A young cat.

Helen was just slipt into bed;
Her eyebrows on the toilet lay,
Away the *kitten* with them fled,
As fees belonging to her prey.
> *Prior*

To LAP. To feed by quick reciprocations of the tongue.

The tongue serves not only for tasting, but for mastication and deglutition, in man, by licking; in the dog and cat kind, by *lapping*.
> *Ray on Creation*

LEOPARD. A spotted beast of prey.

A *leopard* is every way, in shape and actions, like a cat: his head, teeth, tongue, feet, claws, tail, all like a cat's: he

✦✦✦✦✦✦✦✦✦✦✦✦✦✦✦✦✦✦✦✦✦✦✦✦

47

boxes with his fore-feet, as a cat doth her kittens; leaps at the prey, as a cat at a mouse; and will also spit much after the same manner: so that they seem to differ, just as a kite doth from an eagle.

Grew's Musæum

To MEW. To cry as a cat.

Let Hercules himself do what he may,
The cat will *mew*, the dog will have his day.
Shakesp.

PARTY. A number of persons confederated by similarity of designs or opinions in opposition to others; a faction. A select assembly.

Let me extol a cat, on oysters fed,
I'll have a *party* at the Bedford-head.
Pope

To PESTER. To disturb; to perplex; to harass; to turmoil.

We are *pestered* with mice and rats, and to this end the cat is very serviceable.
More's Antidote against Atheism

To PURR. To murmur as a cat or leopard in pleasure.

PUSS. [I know not whence derived; *pusio*, Lat. is a dwarf.] The fondling name of a cat.

A young fellow, in love with a cat, made it his humble suit to Venus to turn *puss* into a woman.
L'Estrange

To SNUG. To lie close; to snudge.

As the loving couple lay snugging together, Venus,

to try if the cat had changed her manners with her shape, turned a mouse loose into the chamber.
L'Estrange

Then, under the adjective WILD, Johnson wrote:

Not tame; not domestick.

For I am he, am born to tame you, Kate,
And bring you from a *wild* cat to a kate,
Conformable as other household kates.
Shakesp.

But, from the evidence of Boswell's *Life*, anyway, and despite his great admiration for Shakespeare, Johnson would not unreservedly have approved of Petruchio's campaign to tame the shrew and break her spirit. Boswell, on the other hand, of a more despotic disposition, as Rousseau noted, would have had no reservations about either Kate or cat. He once wrote a song about marriage, which David Garrick, no less, arranged to be set to music:

In the blithe days of honey-moon,
With Kate's allurements smitten,
I lov'd her late, I lov'd her soon,
And call'd her dearest kitten.

But now my kitten's grown a cat,
And cross like other wives,
O! by my soul, my honest Mat,
I fear she has nine lives.

Meanwhile, the year after Dr Johnson published his great *Dictionary*, Christopher Smart – the prize-winning Cambridge scholar-poet who had been an undergraduate and Fellow of Pembroke College at the same time as Thomas Gray was a Fellow of Peterhouse – began to fall ill, and the illness sometimes took the form of a religious mania which encouraged him to take literally the Biblical advice to 'pray without ceasing', in public places and in private, come rain or shine. As Smart recalled, 'For I blessed God in St James's Park till I routed all the company . . . For the officers of the peace are at variance with me, and the watchman smites me with his staff.' His nephew was to put it another way: 'his various and repeated embarrassments acting upon an imagination uncommonly fervid produced temporary alienations of mind which were attended by paroxysms so violent and continued as to render confinement necessary.'

In the ten years he had been at Cambridge, 1739–49, Christopher Smart had written lighthearted and erotic verses – as well as the more serious formal work which won him prizes – and had run up substantial debts on fine clothes and liquor, for which he was eventually arrested. He was not Gray's type of person at all. Gray prophesied that it would end in tears. 'All this, you see, must come to a Jayl or Bedlam, and that without any help, almost without pity.' And he did not warm to Smart as a poet either. Smart, for his part, had as little time for the uptight Thomas Gray. He once wrote: 'Gray *walks* as if he fouled his small-clothes, and *looks* as if he smelt it'.

Dr Johnson was much more sympathetic to Smart's predicament. He helped the man out by taking on some of his writing commitments in March 1756, and observed to Boswell:

Madness frequently discovers itself merely by unnecessary deviation from the usual modes of the world. My poor friend Smart shewed the disturbance of his mind, by falling on his knees, and saying his prayers in the street, or in any other unusual place. Now although, rationally speaking, it is greater madness not to pray at all, than to pray as Smart did, I am afraid there are so many who do not pray, that their undertaking is not called in question.

When in 1757, at the age of 35, Smart was admitted to St Luke's Hospital for the Insane, subsequently moving to Mr Potter's private madhouse in Bethnal Green, Dr Johnson again saw his madness as less an illness than evidence of a learned man's unconventional kind of genius: 'I did not think he ought to be shut up. His infirmities were not noxious to Society. He insisted on people praying with him; and I'd as lief pray with Kit Smart as anyone else. Another charge was that he did not love clean linen; and I have no passion for it.' Or as Smart himself admitted: 'I am more unguarded than others.' Over the four years between January 1759 and January 1763, while confined in Mr Potter's asylum, he composed the fragments of his magisterial poem-journal *Jubilate Agno* (*Rejoice in the Lamb*), which began with the words:

Rejoice in God, O ye Tongues; give the glory to the Lord,
 and the Lamb.
Nations, and languages, and every Creature, in which is
 the breath of Life.

It was an often obscure and rambling – but always inventive – chorus of praise to the Creator, based largely on the model of the *Benedicite* from the Order of Morning Prayer, the Psalms of David and other parts of the Old Testament in the King James version. The Creator was praised through his creations, in the encyclopaedic form of animals, plants, birds, fish, gemstones, languages, alphabets, figures from the Bible and poets, writers and acquaintances of the day. All are drawn together in the worship of God. Thomas Gray was predictably not among them.

Dr Johnson ('God be gracious to Samuel Johnson') and William Mason ('Lord be merciful to William Mason') were given special mentions. So was 'Pembroke Hall [which] was founded more in the Lord than any College in Cambridge'. Yet it was Mason who wrote unkindly to Gray of Smart's later poems that 'from thence [I] conclude him as mad as ever'. *Jubilate Agno* is like a series of cumulative responsive verses, a kind of canticle to be intoned or sung during a Church of England service. Verses beginning with 'Let' call on an assortment of creatures to praise God; verses beginning with 'For' tend to be more evangelical and personal. The verses work line by line, through repetition, rhythm and distinctively used words, and juxtaposition. All God's creatures worship/adore/give praise to their maker by demonstrating their characteristic natures in all their variety. And at the heart of the poem-journal is a very closely observed description of Christopher Smart's cat Jeoffry, now the most familiar passage in the whole work. This section was written, three verses a day, between the beginning of June and the end of August 1760.

Jubilate Agno builds up to this. In the first fragment of the poem, the 'Let' verses introduce us among many other creatures to the Leopard, the Tyger, the Lion, the Panther and the Civet, then to the Cat 'who is worthy to be / presented before the throne of grace'. The second fragment tells us that 'I am possessed of a cat, surpassing in beauty, from whom I take occasion to bless Almighty God'. In a long catalogue of verses about alphabets, music and language, we are told 'For the power and the spirit of a CAT is in the Greek . . . For the pleasantry of a cat at pranks is in the language ten thousand times over.' Then, at the end of the second fragment, come the seventy-three cumulative and magnificently obsessive verses about Jeoffry the cat – waking up, examining his forepaws, stretching and washing himself; removing fleas, buffeting and seeking food; dallying with a mouse; lying in the sun; and purring. 'Every house is incomplete without him.'

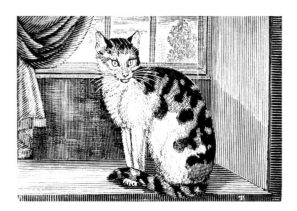

Wood-engraved tabby cat by Thomas Bewick, from his General History of Quadrupeds, *1790.*

He can even 'spraggle upon waggle at the word of command'. English cats, writes Smart, are the best in Europe and Jeoffry is one of the best, for 'God has blessed him in the variety of his movements'. He is, in short, an example of intelligent design.

For I will consider my Cat Jeoffry.
For he is the servant of the Living God, duly and daily
 serving him.
For at the first glance of the glory of God in the East
 he worships in his way.
For is this done by wreathing his body seven times
 round with elegant quickness.
For then he leaps up to catch the musk, which is the
 blessing of God upon his prayer.
For he rolls upon prank to work it in.
For having done duty and received blessing he begins
 to consider himself.
For this he performs in ten degrees.
For first he looks upon his fore-paws to see if they
 are clean.
For secondly he kicks up behind to clear away there.
For thirdly he works it upon stretch with the fore-paws
 extended.
For fourthly he sharpens his paws by wood.
For fifthly he washes himself.
For sixthly he rolls upon wash.
For seventhly he fleas himself, that he may not be
 interrupted upon the beat.

For eighthly he rubs himself against a post.
For ninthly he looks up for his instructions.
For tenthly he goes in quest of food.
For having consider'd God and himself he will consider
 his neighbour.
For if he meets another cat he will kiss her in kindness.
For when he takes his prey he plays with it to give it
 chance.
For one mouse in seven escapes by his dallying.
For when his day's work is done his business more
 properly begins.
For he keeps the Lord's watch in the night against the
 adversary.
For he counteracts the powers of darkness by his
 electrical skin and glaring eyes.
For he counteracts the Devil, who is death, by brisking
 about the life.
For in his morning orisons he loves the sun and the sun
 loves him.
For he is of the tribe of Tiger.
For the Cherub Cat is a term of the Angel Tiger.
For he has the subtlety and hissing of a serpent, which
 in goodness he suppresses.
For he will not do destruction, if he is well-fed, neither
 will he spit without provocation.
For he purrs in thankfulness, when God tells him
 he's a good Cat.
For he is an instrument for the children to learn
 benevolence upon.

For every house is incomplete without him and
 a blessing is lacking in the spirit.
For the Lord commanded Moses concerning the
 cats at the departure of the children of Israel
 from Egypt.
For every family had one cat at least in the bag.
For the English Cats are the best in Europe.
For he is the cleanest in the use of his fore-paws of
 any quadrupede.
For the dexterity of his defence is an instance of the
 love of God to him exceedingly.
For his is the quickest to his mark of any creature.
For his is tenacious of his point.
For he is a mixture of gravity and waggery.
For he knows that God is his Saviour.
For there is nothing sweeter than his peace when at rest.
For there is nothing brisker than his life when in motion.
For he is of the Lord's poor and so indeed is he called
 by benevolence perpetually –
Poor Jeoffry! Poor Jeoffry! The rat has bit thy throat.
For I bless the name of the Lord Jesus that Jeoffry is better.
For the divine spirit comes about his body to sustain it
 in complete cat.
For his tongue is exceeding pure so that it has in purity
 what it wants in music.
For he is docile and can learn certain things.
For he can set up with gravity which is patience upon
 approbation.
For he can fetch and carry, which is patience in
 employment.

For he can jump over a stick which is patience upon
 proof positive.
For he can spraggle upon waggle at the word of command.
For he can jump from an eminence into his master's
 bosom.
For he can catch the cork and toss it again.
For he is hated by the hypocrite and miser.
For the former is afraid of detection.
For the latter refuses the charge.
For he camels his back to bear the first notion of business.
For he is good to think on, if a man would express
 himself neatly.
For he made a great figure in Egypt for his signal services.
For he killed the Ichneumon-rat very pernicious by land.
For his ears are so acute that they sting again.
For from this proceeds the passing quickness of
 his attention.
For by stroking of him I have found out electricity.
For I perceived God's light about him both wax and fire.
For the Electrical fire is the spiritual substance, which
 God sends from heaven to sustain the bodies both
 of man and beast.
For God has blessed him in the variety of his
 movements.
For, tho' he cannot fly, he is an excellent clamberer.
For his motions upon the face of the earth are more
 than any other quadrupede.
For he can tread to all the measures upon the music.
For he can swim for life.
For he can creep.

Jubilate Agno was not intended to be published. Smart, unlike Gray, had no reputation as a poet to speak of in his own lifetime. But since the manuscript was rediscovered and issued in a limited edition – as *Rejoice in the Lamb: A Song from Bedlam* – in 1939, critics have been debating the poem's deeper significance. Did it open the doors of Christopher Smart's perception, or did the madhouse simply protect him from having to earn his living in Grub Street? Has Smart's biography tended to get in the way of his literary achievement by apologizing for it? Did he deliberately shut himself away so that he could worship God without worldly distractions? Or did the music of the verses and their intoning keep the great adversary and the darkness at bay? Maybe he was trying, over and over again, to shake off inherited, more self-conscious forms of poetry and language, to find his own distinctive voice, his special diction. As he wrote in the second fragment, in January 1760: 'For my talent is to give an impression upon words by punching, that when the reader casts his eye upon 'em, he takes up the image from the mould which I have made.'

Maybe his madness was really a reaction against the serenity and tightness of Augustan poetry. Maybe the evocation of Jeoffry the cat, the closely observed cat, was a reply to Selima the cat as immortalized in Thomas Gray's *Ode* – an ode which was by now widely available and much discussed. A Magnificat, of the tribe of Tiger, and 'Angel Tiger' or 'Cherub Cat' to set against Horace Walpole's over-the-top domestic tragedy: this time, a poem about innocence rather than vanity. In Christopher Smart's universe, even goldfish praise the Lord.

Let Jacob rejoice with the Gold Fish, who is an eye-trap.
For I pray God for the introduction of new creatures into
 this island.

His eye-trap. Nor all that glisters, gold. Maybe Smart, locked up in the madhouse, had strong memories of that *Ode* written by the man he saw as cold-eyed and superior, memories unlocked by having Jeoffry the cat with him in his cell. As the illustrator Peter Hay has recently written, 'Cat Jeoffry . . . anticipates William Blake's anti-materialistic energies in all their eclectic glory.' A very long way away from Cat Selima.

Benjamin Britten, who in May 1943 set to music, among other quotations, eight verses of the 'cat' section of *Jubilate Agno* under the title *Rejoice in the Lamb*, wrote to the vicar who had commissioned the Cantata for the choir and organ of St Matthew's Church, Northampton, in defence of his eccentric selection. Evidently, reservations had been expressed about including the 'my Cat Jeoffry' verses in a cantata which would be sung after the Solemn Eucharist – treble voice, spraggling organ accompaniment – on the fiftieth anniversary of the church's conception:

I am afraid I have gone ahead, and used a bit about the
Cat Jeffrey [*sic*], but I don't see how it could hurt anyone –
he is such a nice cat . . . Christopher Smart is a great
inspiration, and I hope you'll be pleased too.

Yours sincerely,
Benjamin Britten

WILLIAM BLAKE'S WATERCOLOURS (1797–98)

૨&

Dr Johnson sternly criticized Gray's *Ode* for the ways in which it shifted register from the feline to the feminine, from the fate of Selima to the fate of presumptuous maids in general with a conventional 'moral' tacked onto its end – 'Nor all that glisters, gold' – which did not seem to fit either cats or women. It was 'of no relation to the purpose'. William Blake, by contrast, made these shifts of register the main subject of his six hand-drawn designs. Selima is sometimes a cat, sometimes a late eighteenth-century woman in a heart-shaped bonnet, and sometimes both at once. Contemporary dress mingles with ancient mythology and even half-and-half humanoid cats. Together, the designs do not really 'illustrate' Gray's *Ode* or even comment on its words, but they present a parallel Blakean story of human frailty (self absorption) leading to possessiveness (desire) and thence to the possibility of redemption (pious prayer). From comedy to divine comedy, as the Blake specialist Irene Tayler has written.

Blake had evidently read the *Ode* with great care, only to use it as a springboard for his own individual interpretation – and to counteract, through pictures, Gray's morbid form of melancholia. One of the keys to the poem, for Blake, seems to have been Milton's Eve in *Paradise Lost* who looked in the 'Smooth Lake' and saw 'A shape within the wat'ry glass' which she admired, soon realizing that she was admiring herself. So instead of the lofty Chinese porcelain tub, Blake presents a shoreline or smooth lake; a bower like the one in the Garden of Eden; armoured fish resembling angels with fins or devils with bat-wings; and a story of the Fall leading to a new spiritual life. Some elements were clearly derived from

the illustrations of Richard Bentley, but by generalizing – or universalizing – the setting Blake detached the *Ode* from Horace Walpole's specific context (the high-camp, artificial world of Strawberry Hill) and related it to his own visionary/prophetic reading. He also detached the *Ode* from the mind-forged manacles, as he saw them, of Gray's high-table cultural world. Blake was not educated to be a literary scholar. He was more comfortable with visual images.

The 116 designs created by William Blake for the poems of Thomas Gray were commissioned half a century after the poems were written, by the Neoclassical sculptor and designer John Flaxman, possibly as a birthday present for his wife Nancy. The volume included a poem by Blake dedicated to Mrs Flaxman, about a little flower replanted in the mountains – a poem which ended on the characteristic line: ''Tis your own fault if you don't flourish now.' Nancy wrote, in early 1797, that 'Flaxman has employed him [Blake] to illustrate the works of Gray for my library'. So this may have been a straightforward commission rather than a surprise. She was already a fan of Blake as a 'Poet and Artist', describing him the previous year as a man who 'sings his wood notes unfettered by any rule – where genius soars above all rule'. Blake was very hard up at the time, following the disastrous commercial failure of his recent engraved edition of Volume I of Edward Young's graveyard poem, *Night Thoughts on Life, Death and Immortality*, a project for which he had produced 537 watercolour designs, only 43 of which had in the end been used: six months' badly paid labour. Flaxman may have been helping Blake out with the Gray commission – though Blake 'asked

◆◆◆◆◆◆◆◆◆◆◆◆◆◆◆◆◆◆◆◆◆◆◆◆

Title page of Edward Young's vast graveyard poem
Night Thoughts, *designed and engraved by William Blake in 1796–97. The volume, covering the first four* Nights, *was not a success.*

only ten guineas for the designs, which is the price of friendship, not commerce'.

The format Blake used, when 'illuminating' Gray's words, was the same as he had developed for *Night Thoughts.* He had never used it before 1796–97, and he would never use it again, after the Gray volume. The margins of the printed pages 43–158 of John Murray's new edition of *Poems by Mr Gray* (1790) were pruned, to make cut-out sheets 5½ inches high by 3¾ inches wide (14 × 9.5 cm). These were then glued from the back to appear in smaller rectangular windows cut into sheets of folio-sized drawing paper (the paper, watermarked 1794, was left over from the *Night Thoughts* project; Blake had been given it in 1795). The windows were high and not quite centred, alternately to the left and to the right. To disguise the edges, Blake drew a thin red line around the text boxes. The cutting and pasting may have been performed by someone who had worked on *Night Thoughts* at publisher Richard Edwards's, or by Catherine Blake at home: either way, it was a very careful fit, which was evidently intended from the start of the project to be bound as a book. The designs dwarfed the text boxes, and there was a disjunction – which must have been deliberate – between the mechanically printed text and the freedom of the drawings. Blake could easily have presented the text in his own handwriting, but chose not to – except for the introductory lists of designs for each poem, which were informally and scrappily handwritten. The designs were initially drawn in pencil or ink, then strengthened or sometimes altered with ink or paint: pen and watercolour over pencil and pen.

The volume was much prized by Mrs Flaxman, and she rarely let anyone see or touch the designs. It remained in her library until 1828, when 'A copy of Gray's poems, illustrated by Wm Blake' was sold as part of the Flaxman estate by Christie's for eight guineas. Nancy had died in 1820 and John Flaxman six years later. It was purchased by a book dealer and eventually found its way, via William Beckford of *Vathek* and Fonthill fame, into the Hamilton Palace library. But when that library was dispersed and sold in 1882, the Gray designs were not part of the sale. It was only in 1919, when Hamilton Palace was being dismantled, that the volume was accidentally discovered hidden behind a shelf. Three years later, it was published for the first time – one hundred and twenty-five years after Blake made the original watercolours – in a full-sized limited edition with all 116 plates in monochrome and a few in colour. Only in the early 1970s was a full-colour edition of the entire sequence published.

Blake's first two designs for the *Ode on the Death of a Favourite Cat* introduce the viewer/reader to the main themes – as he saw them. Design 1, which includes Murray's printed title, reflects the opening lines of Gray's third stanza:

> Still had she gaz'd; but 'midst the tide
> Two angel forms were seen to glide

It shows a grotesque Selima, with the body of a cat and the face of a human (only with pointed ears, red eyes and long whiskers and eyebrows), dressed in a blue corselet and white bonnet and shawl, sitting on the text box as she reaches with a furry arm – claws extended – towards the water and the fish. The text box is treated as if it was a solid object. Behind her is an ominous cloud in a blue sky. Below, in blue-green water, the two goldfish are also part-animal, part-human, with fins which are also wings ('Angel forms'), gargoyle-like faces and human legs. Their torsos have 'scaly armour', like ancient breastplates. The upper of the two fish opens his arms wide, provocatively, as if drawing Selima to come and get him. This design has been called 'a leering exchange between two hybrid forms'.

Design 2 has Blake's handwritten design titles for the whole sequence in the text box. This time Selima has become all cat, a tabby cat, reclining on the box and facing in the opposite direction to Design 1. She is not exactly demure: too alert for that. The sky is white, with a yellowish cloud, and the lake or sea is blue. The two goldfish are now fish. But sitting astride each creature is a human figure. Squatting on the cat's back – and staring out at the viewer, head on hand – is a 'nymph', in a late eighteenth-century hairdo; and sitting on the fishes' backs are two underwater classical sprites with flowing hair, evoking the Nereids in the sixth stanza.

There is no continuity of space and scale between the first and second designs, except the cloud. The first one introduces the viewer to the themes of vanity, desire and hunter/hunted; the second to the parallel stories of cat and 'hapless nymph'. Blake's strongest narrative innovation, so far, is to include the goldfish as characters in the allegory – which Gray never did.

Design 3 accompanies some selected lines from Gray's first and second stanzas: 'The pensive Selima' and 'Her Ears of Jet,

and Emerald Eyes, / She saw; & purr'd applause.' In the text panel are the title and opening stanzas of the *Ode*. Selima has become a contemporary woman in a long dress with heart-shaped bonnet, reclining on the grass. Her 'conscious tail' appears above the text box. She has a cat-like face and cat's ears, and is admiring her own reflection in the water. But the reflection does not show any of her catlike features: she is simply a late eighteenth-century woman. In the water, a lake as it has become, various flowers are growing as if they were a bower in a Garden of Eden. Among the flowers are two goldfish/angels/'Genii of the stream', a male and female again, embracing each other – in contrast to the languid vanity of Selima. The water world seems to be more sensual than the above-ground world.

Design 4 refers to the first two lines of Gray's third and fourth stanzas:

> Still had she gaz'd; but 'midst the tide
> Two angel forms were seen to glide
>
> . . .
>
> The hapless nymph with wonder saw:
> A whisker first, and then a claw

Selima has become a tabby cat again. But not all cat. She has a cat's head and forepaws, whiskers, eyebrows and claws, but from the waist down she is covered in part of a woman's dress and she has human feet. Behind her, in a reclining posture, is the iconic and grim figure of Fate just about to cut the thick thread of Selima's life with a pair of shears. In the water, the two 'Genii of the stream' glide by, with human bodies and angelic/bat-like/finny golden wings. Selima is gazing at them in a predatory way, ready to jump.

Design 5 accompanies three lines from the end of Gray's fifth stanza:

> (Malignant fate sat by, and smil'd)
> The slipp'ry verge her feet beguil'd,
> She tumbled headlong in.

At the top of the picture, the figure of Fate, sitting cross-legged, leans to the right and stretches out her arms over Selima. Evidently, Fate has just pushed the cat/woman into the water – unlike Gray's 'malignant fate' who just 'sat by, and smil'd'. And the slippery verge evidently has not 'beguil'd' the cat's feet: in this version she has been pushed. Selima in turn has become a fully human woman, and is falling headlong into the murky water, her long hair tangled with her feet and dress. The two goldfish/angels are swimming upwards towards the surface, and they now look as though they were dressed for battle: the male has a shield and fish-hook, the female a spear and hook, and both have scales or armour. Blake seems to have taken literally Gray's line in the third stanza, 'Their scaly armour's Tyrian hue'. The male fish makes an aggressive face at the woman, the female looks apprehensively over her shoulder. Earlier designs have pre-pared the viewer for this development. The fish have become the attackers, and the cat has become defenceless. The water is noticeably darker.

Blake's final design, Design 6, alludes to the first two lines of Gray's sixth stanza. Selima, a young woman again, is floating or 'emerging' from the grey-blue water, her head and shoulders above the surface, with her hands clasped in prayer, her face looking heavenwards and her mouth open. Gray wrote 'Eight times emerging from the flood'; but in his hand-written titles in Design 2 Blake quotes the lines as

> Nine times emerging from the flood
> She mewed to every wat'ry God

and the suggestion is that Selima has died to be redeemed as spiritual being. Above the shore, there is the outline of a grassy hill with trees, the only recognizable landscape in the whole series. Have the cat-like elements – the vanity, wantonness, self-absorption, and aggression – died within her, to enable her to be reborn as a fully fledged human being? Has she fallen, like Eve, to be redeemed after her nine lives have been wasted? Or is Selima simply dead and on her way to paradise? Is the landscape heaven or earth? The shifts of register in Gray's *Ode* – the death of the cat, 'one false step is ne'er retrieved', 'Not all that tempts your wand'ring eyes . . . is lawful prize', 'Nor all that glisters, gold' – are matched by the ambiguity of Blake's final design. Meanwhile the fish, who were warlike in the previous designs, have become realistic goldfish again, swimming away, glassy-eyed as if the drama had nothing to do with them.

Unlike Gray and Bentley, then, Blake does not view the moral of the tale with amused and ironic detachment. He sees it as a version of the Fall, the story of a fashionable and conventional young woman who goes on a journey of self-discovery from vanity and possessiveness to a higher form of humanity. Ever since I first encountered this series of designs, at the Tate Gallery's 'William Blake' exhibition in spring 1978 – where Design 3, 'The pensive Selima', the first page of the poem, was exhibited – I have been intrigued by its relationship with the words on the page. Clearly Blake knew the poem well, and he took much of it literally, but text and design exist in their own worlds. Is this, as critic Northrop Frye once asked, graphically illuminated poetry or poetically embroidered painting? Is it a 'radical form of mixed art'? There are some who feel that Blake's images are too dominating, that they distort Gray's intentions in trying to 'correct' his words. Others feel that the images are closer to Blake's visionary works than to Gray's poetry. Mrs Flaxman's response was that 'He has treated his poet most Poetically'.

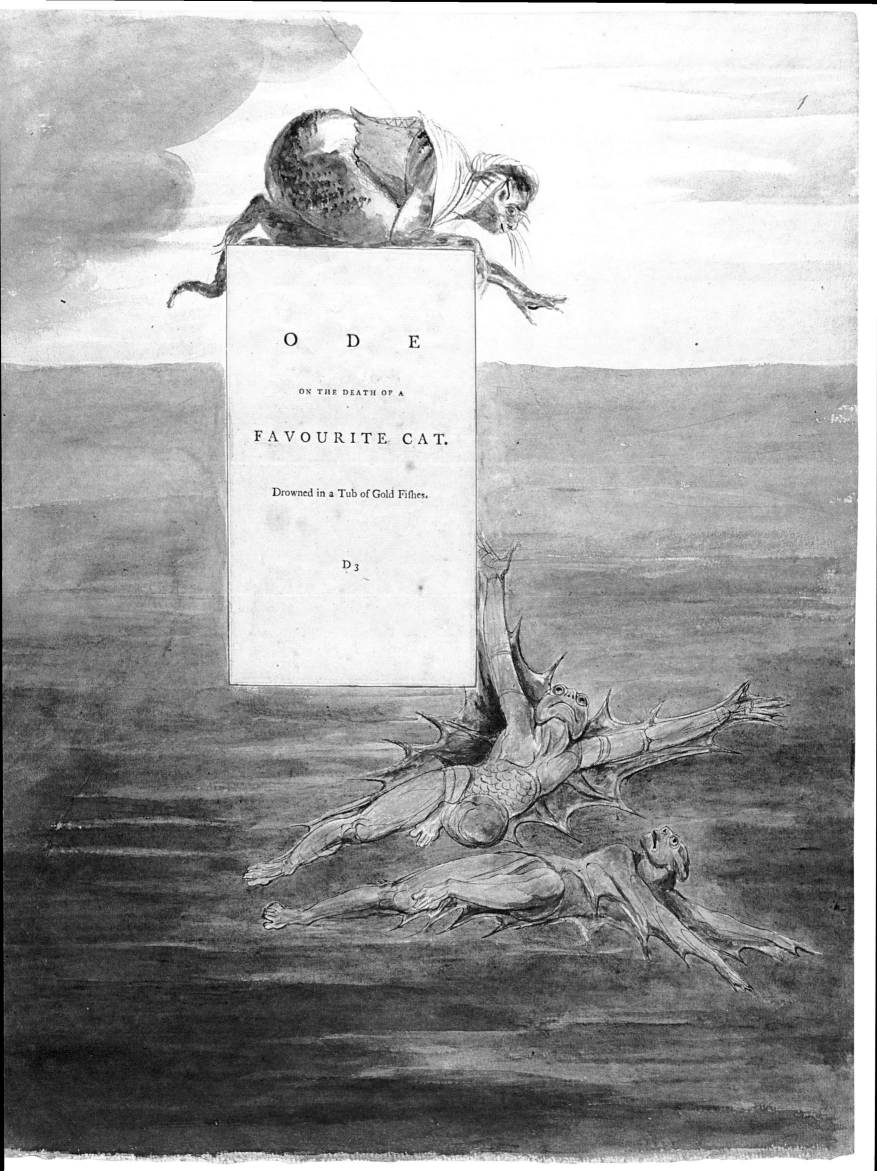

ODE

ON THE DEATH OF A

FAVOURITE CAT.

Drowned in a Tub of Gold Fishes.

D 3

Ode on the Death of
a Favourite Cat

Design.

1. "Midst the tide
Two Angel forms were seen to glide"

2. "Demurest of the Tabby kind."

3. "The pensive Selima
Her Ears of Jet & Emerald eyes
She saw & purr'd applause"

4. "Still had she gaz'd but midst the tide
Two Angel forms were seen to glide
The hapless nymph with wonder saw
A Whisker first & then a Claw &c"

5. "Malignant Fate sat by & smil'd
The slippery verge her feet beguil'd
She tumbled headlong in"

6. "Nine times emerging from the flood
She mew'd to every watery God"

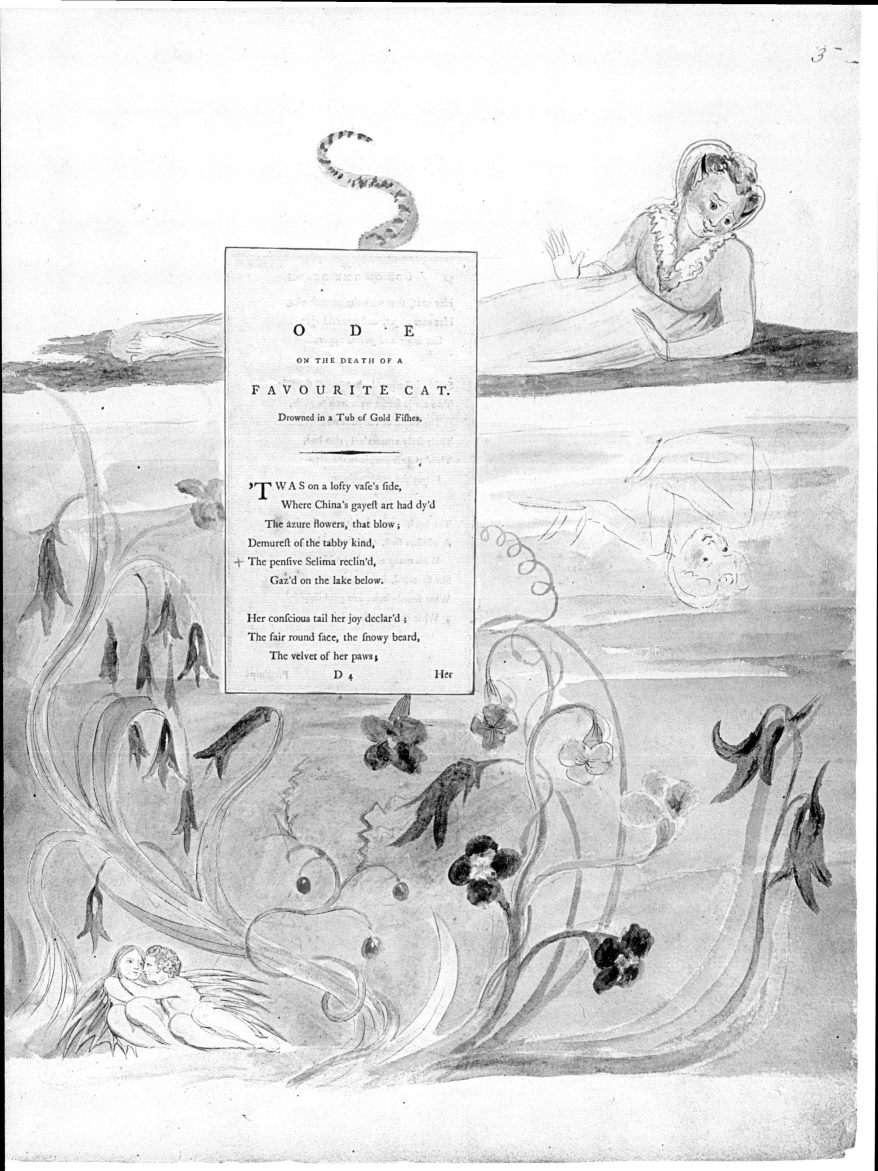

ODE

ON THE DEATH OF A

FAVOURITE CAT.

Drowned in a Tub of Gold Fishes.

———

'TWAS on a lofty vase's side,
Where China's gayest art had dy'd
The azure flowers, that blow;
Demurest of the tabby kind,
† The pensive Selima reclin'd,
Gaz'd on the lake below.

Her conscious tail her joy declar'd;
The fair round face, the snowy beard,
The velvet of her paws;

D 4 Her

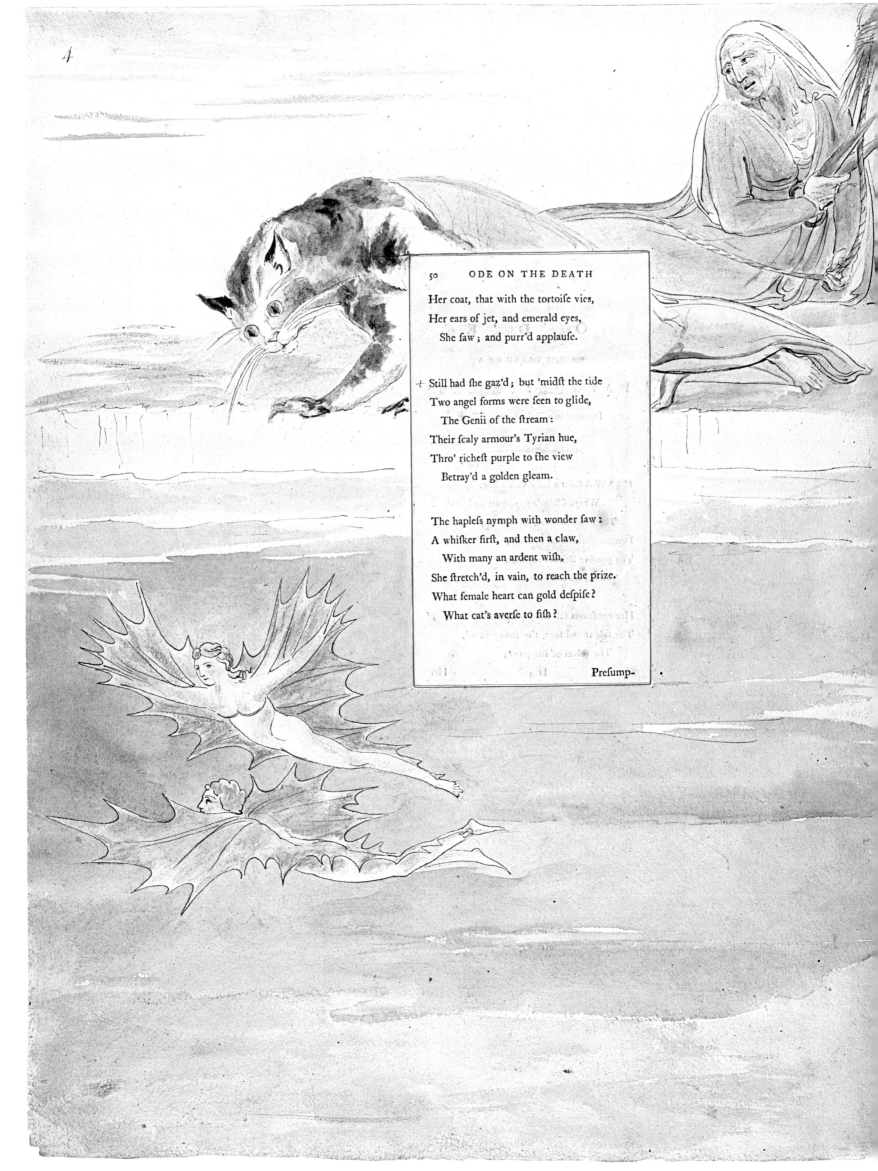

50 ODE ON THE DEATH

Her coat, that with the tortoise vies,
Her ears of jet, and emerald eyes,
 She saw; and purr'd applause.

✝ Still had she gaz'd; but 'midst the tide
Two angel forms were seen to glide,
 The Genii of the stream:
Their scaly armour's Tyrian hue,
Thro' richest purple to the view
 Betray'd a golden gleam.

The hapless nymph with wonder saw:
A whisker first, and then a claw,
 With many an ardent wish,
She stretch'd, in vain, to reach the prize.
What female heart can gold despise?
 What cat's averse to fish?

 Presump-

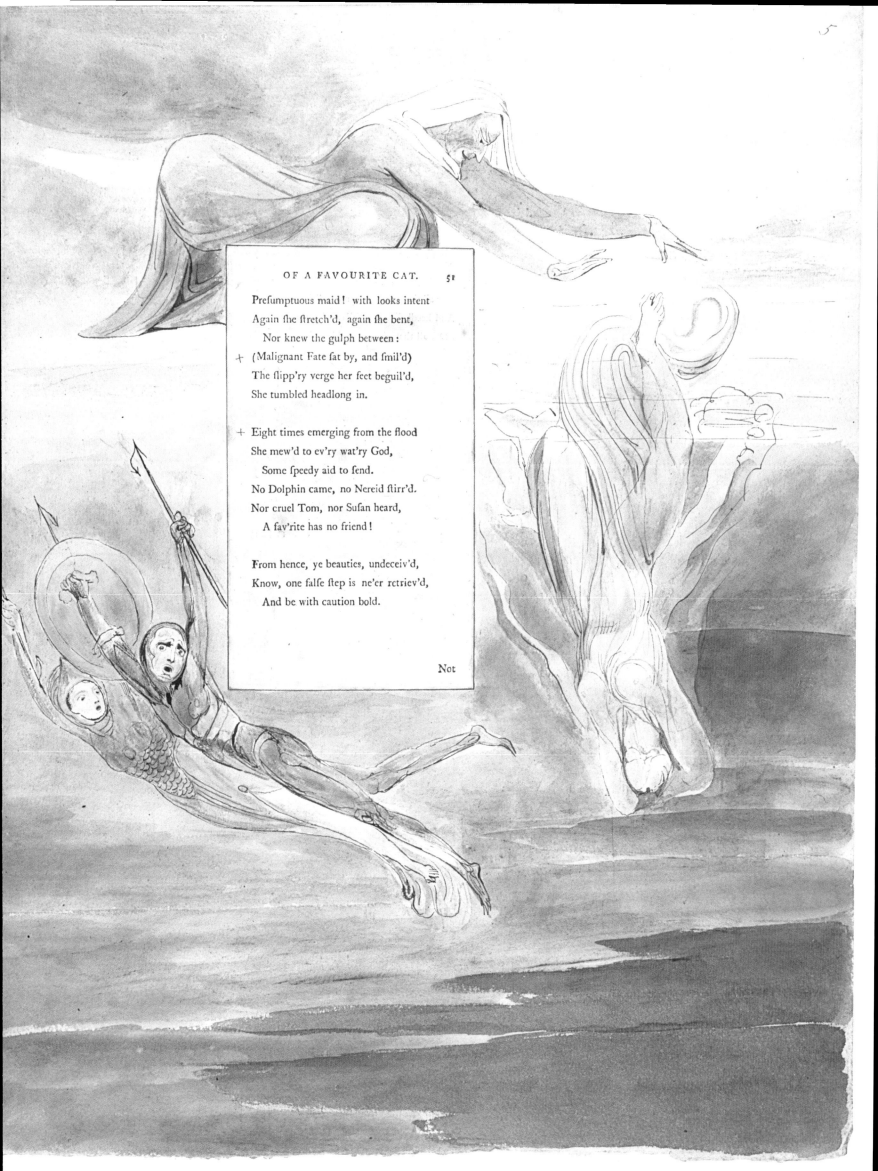

OF A FAVOURITE CAT. 51

Presumptuous maid! with looks intent
Again she stretch'd, again she bent,
 Nor knew the gulph between :
✛ (Malignant Fate sat by, and smil'd)
The slipp'ry verge her feet beguil'd,
She tumbled headlong in.

✛ Eight times emerging from the flood
She mew'd to ev'ry wat'ry God,
 Some speedy aid to send.
No Dolphin came, no Nereid stirr'd,
Nor cruel Tom, nor Susan heard,
 A fav'rite has no friend!

From hence, ye beauties, undeceiv'd,
Know, one false step is ne'er retriev'd,
 And be with caution bold.

Not

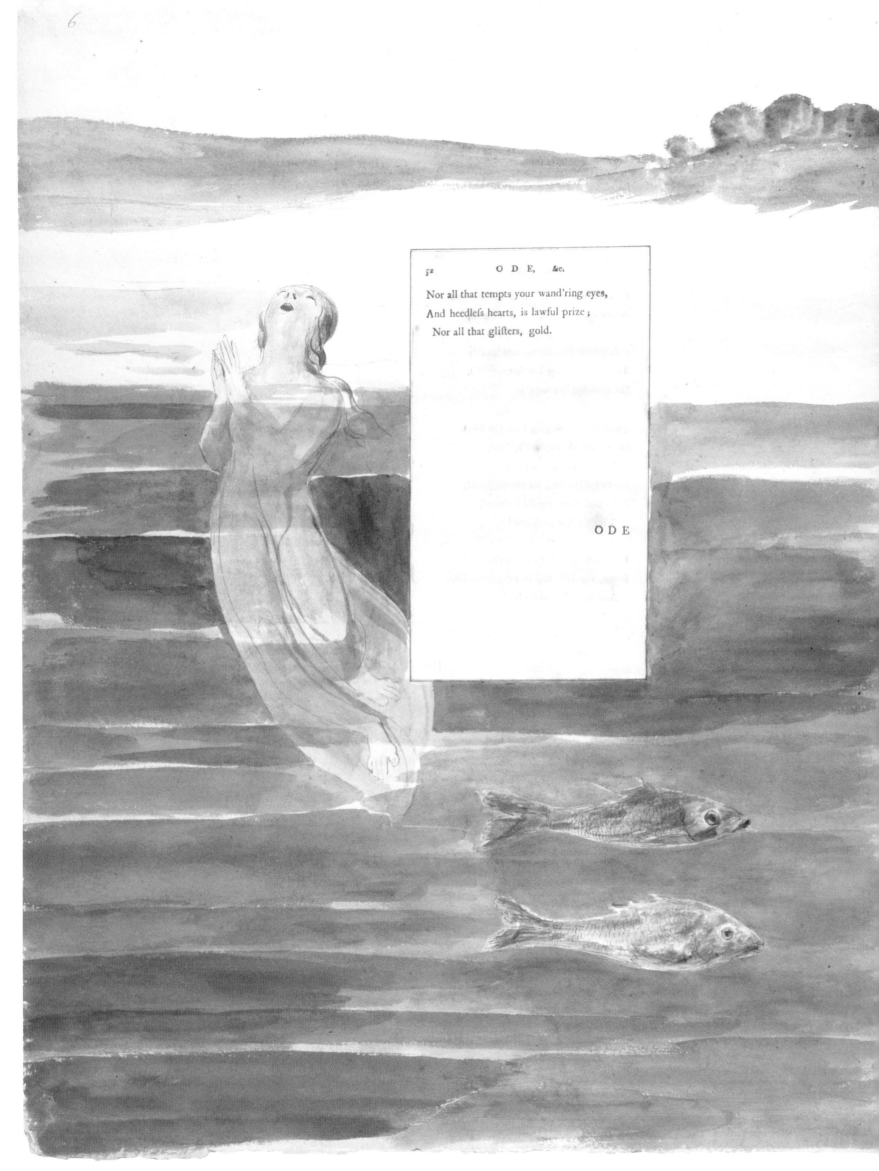

52 O D E, &c.

Nor all that tempts your wand'ring eyes,
And heedlefs hearts, is lawful prize ;
 Nor all that glifters, gold.

O D E

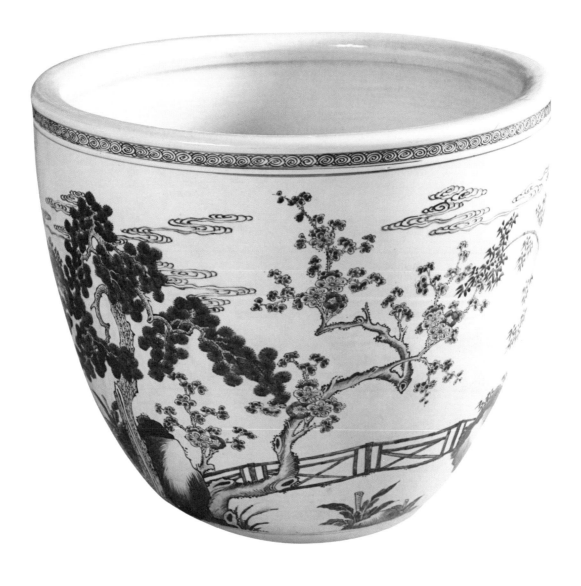

'Twas on this lofty Vafe's Side,
Where CHINA's gayeft Art has dy'd
 The azure Flowers, that blow;
Demureft of the tabby Kind,
The penfive SELIMA reclin'd,
 Gaz'd on the Lake below. *&c.* GRAY.

KATHLEEN HALE'S ILLUSTRATIONS (1944)

୬

Kathleen Hale's illustrations were prepared as roughs in 1944 for a 'rather de luxe' edition of Thomas Gray's poem, which was to be a short picture book. Noel Carrington, brother of Dora, and the man who, as an editor of *Country Life*, had published all the early *Orlando the Marmalade Cat* books, was sent these roughs at his company, Transatlantic Arts Co. Ltd, of 45 Great Russell Street, London, and wrote back to the artist at her house in South Mimms on 4 May 1944:

> Dear Kathleen.
>
> *Poem to a Cat*
>
> I am returning your roughs. I have given them a great deal of thought, and also tested opinion at home. My feeling is favourable to go on …
>
> One or two questions occur to me: one is whether you will be able to get your [lithographic] effects with only three colours and black, or whether you will want a grey? For many reasons, it is best to avoid grey if possible.
>
> I think it would be best to have the lettering on the front carefully done by a letterer following carefully to your design in a book which is rather de luxe.
>
> The paper will be a little smaller than this [9 × 6 inches/*c*. 23 × 15 cm] but to the same proportion, and I will get Geoffrey [Smith, proprietor of the printers who produced the lithographs] to photograph down the keys to fit the page.
>
> Yours,
> Noel Carrington

P.S. When all is said and done, I do not want you to force yourself to finish this job if it turns out to be against your own feelings. If you would rather make it, say, a 16 page story in your familiar style of *Henrietta* [*the Faithful Hen*, who had appeared the year before, published by Transatlantic Arts], or *Orlando* I think the paper would run to it [at a time of wartime paper rationing] but I am all for breaking new ground and so my suggestion is to go ahead. NC

P.P.S. For various reasons, I find this letter did not go off over the weekend, and I am adding one consideration which is that for a Christmas gift it might be as well not to emphasise too much the funeral character of the title page. Perhaps the goldfish still swimming could figure.

Kathleen Hale was and is celebrated as the author and illustrator of the *Orlando the Marmalade Cat* books – starting with *Orlando the Marmalade Cat: A Camping Holiday*, published in 1938, followed by seventeen sequels up to 1972. After the first one, for all the books she prepared lithographic plates in four colours at home in South Mimms on the long kitchen table – 128 adapted zinc plates for the 32 pages of each book, so one large-format *Orlando* would take four to five months to produce, seven hours a day, seven days a week. The plates were then sent in crates to Cowell's in Ipswich (which started out 'next to a wine shop'), to be printed by offset.

The early stories – *A Camping Holiday* (1938), *A Trip Abroad* (1939), *Orlando's Evening Out* (1941), *Orlando's Home*

Life (1942), *Orlando Buys a Farm* (1942) – were published by Carrington initially for *Country Life* (the first two, in folio format) and then for the new Puffin Picture Books with Penguin (the next two). *Orlando's Evening Out* was in fact one of the first Puffin Picture Books to be issued. The success of the cheaper Puffin editions, which advertised the folio-format stories on their jackets, helped the first two stories to 'become the rage'. The description of Orlando which opened *A Camping Holiday* became famous: 'Orlando was very beautiful, striped like marmalade and the same colour; his eyes reminded you of twin green gooseberries.'

When Kathleen Hale was 92 years old (she died in January 2000 at the age of 101), I visited her in her old stone house in rural Oxfordshire, and asked her about the advantages of being her own printmaker, from *A Trip Abroad* onwards:

> Well it helped to get the spontaneity of line – the *scoop* of it – which is very useful when you are trying to draw cats. They're very difficult to draw because they're fluid. You don't see the bones. And I managed to get an x-ray photograph – can't *think* where – of a cat's skeleton, and that was a great help to me. Of course, with a Persian cat you can't know *what's* going on underneath all that fuzz. I got the idea, though, by feeling our cat, and nursing it, and loving it generally – and looking at this x-ray thing. After all, most students of life drawing have to draw skeletons – the human skeleton: that helps enormously. And George Stubbs, of course, dissected a horse didn't he, to get to the skeleton?

Indeed he did. When she was preparing her roughs for *Orlando*, she was always drawing her own cats at home in Rabley Willow, South Mimms:

> I was constantly sketching my cats, and their behaviour – active or asleep – gave me all sorts of ideas for the stories. For instance, Orlando, meticulously washing the base of his tail with his hind leg up in the air, became the 'World Famous Imitation of a Ham' in *A Trip Abroad*.

The Noel Carrington who saw the potential of Kathleen Hale's first two books was the same man who had edited and published all the Design and Industry Association publications in the 1920s, was deeply involved in the Society of Industrial Artists, and was even then preparing his book *The Shape of Things: An Introduction to Design in Everyday Life*. Since he also helped to initiate the early Puffin Picture Books with Penguin it may well have been that he had seen in Kathleen Hale's stories – with their well-designed layouts and their celebration of traditional British craftsmanship – useful examples of, as he put it, 'good design in the home'. It was Noel Carrington who selected the clean modern typography which blended in well with Hale's chalky pictures, as she explained to me:

> Yes, you're quite right about his career. But I think his first reaction was 'they would be a winner'. When Geoffrey Smith put the first two books in front of Noel Carrington, they agreed that if the illustrations were turned into four

colours, they would become viable financially. And that made the books possible. They were much, much better for it. Up to then I was using pale grey and pale pinks, whereas if you used the primary colours you could get all that. My introduction to Noel Carrington in the offices of *Country Life* in Covent Garden completely changed my life.

Perhaps, I suggested, Noel Carrington also recognized that the stories chimed with the aims of *Country Life* itself: Orlando enjoys taking his wife Grace and the three kittens for a spin in the family saloon, around the countryside: and, although the predominant tone is far from nostalgic, the pastel-coloured background to the stories is – more often than not – 'village England'. Then they return home for some wholesome haddock milk.

Maybe. But that's where I lived you see. That farm and everything was the farm next door to us and the church was our church, and I believed that if you really drew things as they were, from your own experience, they would come through as real in the book. The village was near Elstree. South Mimms, actually.

In *Orlando Buys a Farm* (1942) though, there does seem to be a clear example of Arts and Crafts thinking. The farm-horse Vulcan takes issue with Orlando who wants modern technology in the form of the tractor to work the hay elevator: 'but Vulcan objected "I've always done it and I always will."' And there are many other examples of a latter-day William Morris view of the world in the Orlando books:

Oh, come off it! That's just the horse. A horse world. That's what the *horse* was thinking . . . That would have been in my mind the whole time when I wrote the early stories, but not so much in those days.

Maybe the work of other artists was in her mind, too? 'Oh please don't mention Louis Wain's cats. I can't *stand* them.' No, the artist I was about to mention was William Blake. I showed Kathleen Hale two illustrations from *Orlando the Marmalade Cat: A Camping Holiday* – one of the cat crouching on the bank of the river, with little fish rising to him, the other of his kittens swimming in a mountain stream where 'there were all sorts of interesting things in the water, some of which they ate' – and wondered if Blake might have inspired them. After all, there was a strong Blake revival in the 1920s, when Hale was mixing with some of the most celebrated painters and printmakers of her day, including a stint as Augustus John's personal assistant, and Blake's designs for Gray's *Ode* were first published in monochrome in 1922, amid considerable publicity:

Oh, my dear they are *exactly* like mine. They are, aren't they? My cats go under water too but they don't drown. There's the one where the kittens are bathing with the creatures alive and the fish hiding under the bank, and there's Orlando tickling the surface of the water with the

❖❖❖❖❖❖❖❖❖❖❖❖❖❖❖❖❖❖❖❖

68

tips of his whiskers and the sleepy little fish think his whiskers are flies dancing on the stream. Exactly like mine. But I'm rather cross with you. You'd better keep quiet about it!

Did she remember seeing the Blake designs? 'I don't remember ever seeing them, but it was a very long time ago. I did remember a wonderful snarling cat by Hogarth, but that was definitely later.'

Maybe her drawings also owed something to Gwen John's small pencil and watercolour studies of cats?

I never met her, when I was working for Augustus. She was a recluse living in France. I know that Augustus thought she was the finest artist of the two. I love her work almost more than anyone, but I don't think I ever saw her cat drawings at that time. Perhaps I should have done. Her colour, in a narrow range, is wonderful – black and brown and grey.

The proposed edition of the *Ode to a Favourite Cat* would have been published by Carrington's Transatlantic Arts (like *Henrietta* in 1943 and like *Orlando's Invisible Pyjamas* in 1947 – 'this was Noel's company, but it didn't last very long'), and printed at Cowell's with advice from the firm's lithographic department. The style of drawing was unmistakable. But the edition would also have broken new ground for both Hale and Carrington. A well-known poem rather than an original story told with the pictures in mind; an unhappy ending

(even if Hale had in the end chosen 'not to emphasize too much the funeral character of the title page') rather than the usual scene of Orlando spending the evening with Grace and the children; six illustrations for the seven stanzas – two of them accompanying two stanzas – rather than the usual profusion of visual material across thirty-two pages . . . a 'rather de luxe' book.

The treatment of the poem is interesting – and again seems to relate at times to Blake. The title page, with the characteristic Kathleen Hale lettering of *Orlando* title pages, shows Selima lying on a funeral bier, surrounded by four lit candles. Between her paws is a lily. This was the illustration with its 'funeral character' which worried Noel Carrington. Perhaps some live goldfish could figure? Was it too gloomy, for such gloomy times? The second illustration, to accompany the first and second stanzas of the poem, shows a pampered and pensive Selima gazing at her bowl-shaped reflection below: she saw; and purred applause. The third, to accompany the third and fourth stanzas, shows the ribboned Selima stretching a velvet paw in vain to reach the 'two beauteous forms' of the goldfish in a big round tub. There's no reference, though, to the 'hapless nymph' or the 'female heart'. This is a tabby cat disturbing the water as she reaches intently for some fish. The fourth illustration, to accompany the fifth stanza, shows 'Malignant fate' with a sinister smile holding the thread of Selima's life, as the cat tumbles headlong with a splash into the tub, with its blue-and-white Chinese decorations. 'Malignant fate' seems to be looking down on the tub from the sky, rather than from indoors.

The tub itself, though, is a real example of 'China's gayest art'. The fifth illustration, to accompany the sixth stanza, shows two half-naked Nereids/mermaids – who appear to be wearing frilly knickers with bows – riding with glee two dolphins. Above them, Neptune the 'wat'ry God' holds in one hand his trident and in the other a half shell with two fish skeletons in it. He is wearing a cloak of seaweed, and again the background is the sky. At the bottom of the picture, we see Selima's two front paws disturbing the water, as if trying to swim. Eight times emerging from the flood. The implication of this – Kathleen Hale's own interpretation – is that Selima did indeed catch the fish, but died as she did so. The final illustration, which accompanies the seventh and last stanza of the poem, shows a fish, a bird, a cat and a rat as angels flying down towards a tree, the tree of knowledge which is being scaled by three women on ladders: two of these women are fair, long-haired and naked with 'heedless hearts', the third – facing us – is the dark lady. Know, one false step is ne'er retrieved. The heedless women are reaching out for an apple with a snake in it. There are apples on the ground below.

Like Blake, Kathleen Hale interprets the poem as a version of the Fall – albeit a light-hearted one.

In the end, although Noel Carrington had given her the go-ahead, for her own reasons Kathleen Hale preferred to work on the much more upbeat *Orlando the Marmalade Cat: His Silver Wedding* and *Orlando the Marmalade Cat Becomes a Doctor*, both folio-sized editions published by *Country Life* in 1944. Maybe the job *did* turn out to be against her own feelings. Maybe it had been Noel Carrington who'd originally suggested it to her. Maybe she felt more at home with her own 'familiar style of . . . *Orlando*'. Or maybe in Summer 1944, when the war was still being fought, she came to agree with Carrington's P.P.S. that the *Ode* contained too much of a 'funeral character'. Whatever the reason, this set of exquisite illustrations has never been published as a set before.

The verses from Gray's *Ode* for which Kathleen Hale intended her drawings have been added (in the standard version) to the 'boxes' she left on each page. They are set in Bodoni, the type-face recommended in a pencil note on the third drawing.

On a
Favourite Cat,
Drowned in a Tub of
Gold-fishes.
By
Thomas Gray

Illustrated by
Kathleen Hale.
Transatlantic Arts Ltd: London & New York.

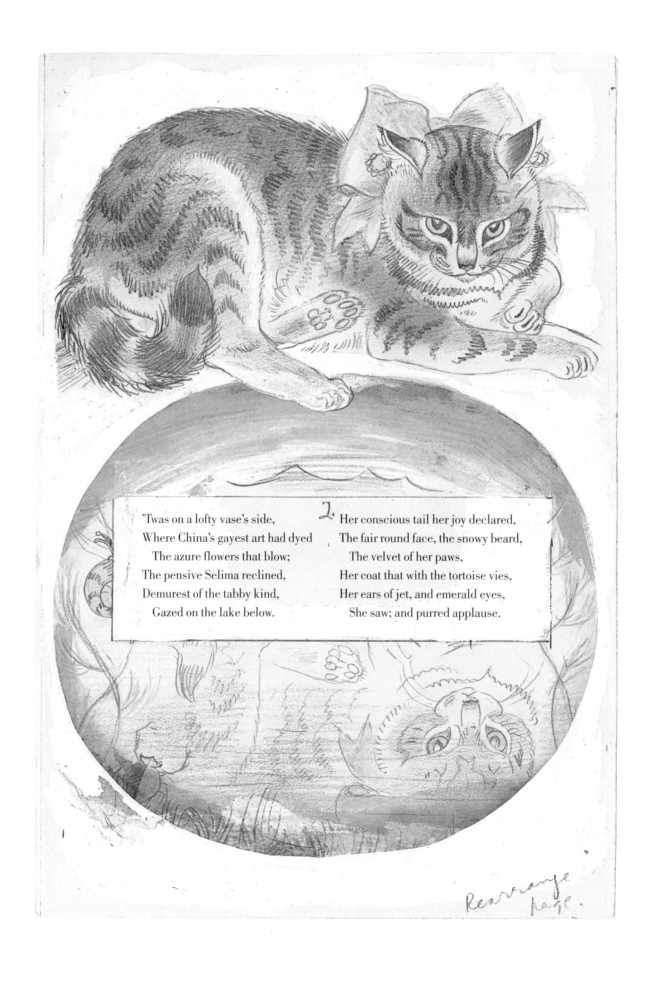

'Twas on a lofty vase's side,
Where China's gayest art had dyed
 The azure flowers that blow;
The pensive Selima reclined,
Demurest of the tabby kind,
 Gazed on the lake below.

2. Her conscious tail her joy declared,
The fair round face, the snowy beard,
 The velvet of her paws,
Her coat that with the tortoise vies,
Her ears of jet, and emerald eyes,
 She saw; and purred applause.

Rearrange page.

Still had she gazed: but 'midst the tide The hapless nymph with wonder saw:
Two beauteous forms were seen to glide, A whisker first and then a claw,
 The genii of the stream: With many an ardent wish,
Their scaly armour's Tyrian hue She stretched in vain to reach the prize
Through richest purple to the view What female heart can gold despise?
 Betrayed a golden gleam. What cat's averse to fish?

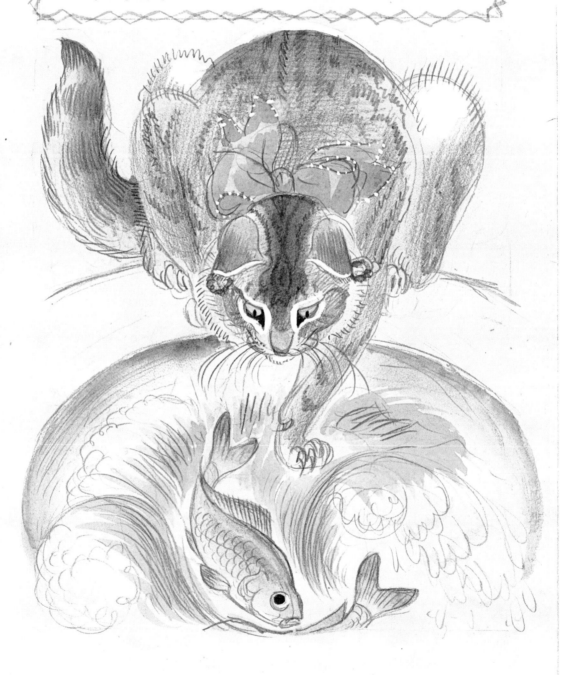

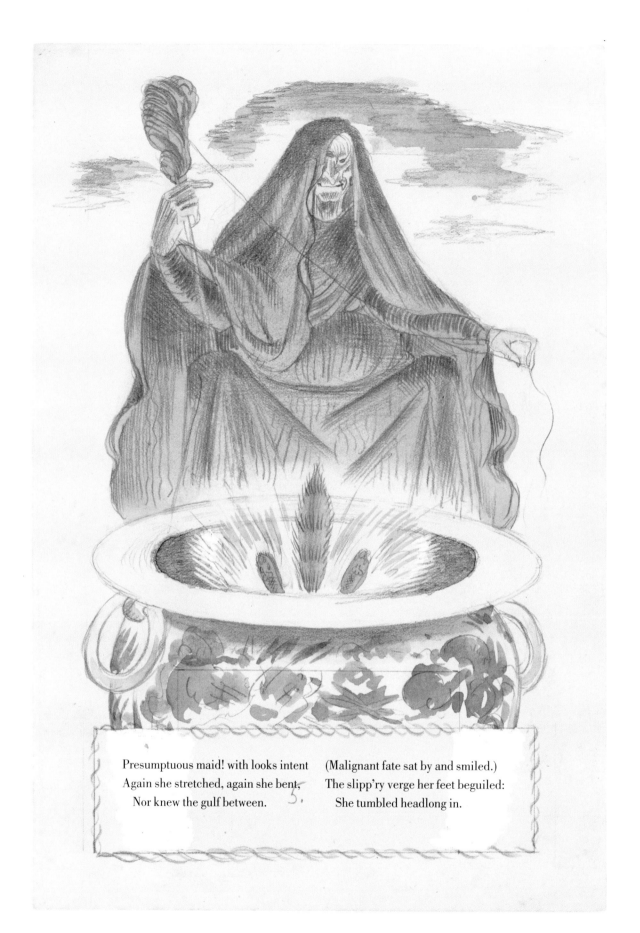

Presumptuous maid! with looks intent (Malignant fate sat by and smiled.)
Again she stretched, again she bent, The slipp'ry verge her feet beguiled:
 Nor knew the gulf between. She tumbled headlong in.

Eight times emerging from the flood No dolphin came, no Nereid stirred
She mewed to ev'ry wat'ry God Nor cruel Tom, nor Susan heard.
Some speedy aid to send. What fav'rite has a friend?

6.

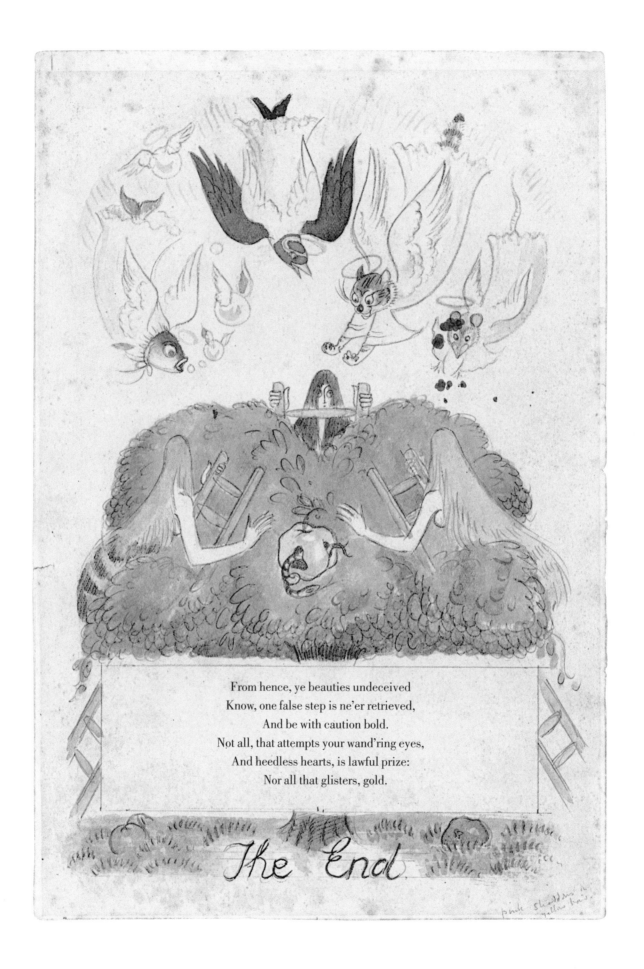

From hence, ye beauties undeceived
Know, one false step is ne'er retrieved,
And be with caution bold.
Not all, that attempts your wand'ring eyes,
And heedless hearts, is lawful prize:
Nor all that glisters, gold.

The End

NOTES ON THE ILLUSTRATIONS

෧෴

page 2 Horace Walpole: mezzotint engraved as a private plate for Walpole by James McArdell, 1757, after the portrait by Sir Joshua Reynolds, 1756–57. Collection of David Alexander

page 9 Dr Samuel Johnson: mezzotint by William Doughty, 1779, after a portrait by Sir Joshua Reynolds, *c.* 1772–78. Collection of David Alexander

page 11 Horace Walpole in the library at Strawberry Hill: watercolour by J. H. Müntz, *c.* 1755–59. Private collection. Photo Paul Mellon Centre for Studies in British Art, London

page 20 left Horace Walpole's Chinese porcelain tub, *c.* 1730. The Derby Collection, Knowsley, licence granted courtesy of the Rt Hon. The Earl of Derby 2008

page 20 right Detail from the frontispiece to the *Ode on the Death of a Favourite Cat* (see below, *pages 34–37*)

page 25 Thomas Gray: engraving by J. S. Muller, 1753, after the portrait by J. G. Eckhardt, 1747. Collection of David Alexander

pages 34–37 The *Ode on the Death of a Favourite Cat*, with engravings by Charles Grignion after Richard Bentley, from *Designs by Mr. R. Bentley for Six Poems by Mr. T. Gray*, published by Robert Dodsley, 1753

page 38 Horace Walpole's 'Explanation of the Prints', published by Robert Dodsley, 1753

page 42 The Chinese tub in position at Strawberry Hill (detail), from Horace Walpole's extra-illustrated copy of the second edition of the *Description of Mr Horace Walpole at Strawberry Hill*, 1784

page 42 Title-page of Jean-Jacques Rousseau, *Discours sur l'origine et les fondemens de l'inégalité parmi les hommes*, Amsterdam, 1755. Photo R. B. Fleming

page 45 left James Boswell: engraving by Edward Finden 'from an original sketch by the late George Langton, Esqʳᵉ', published by John Murray in 1835

page 45 right Jean-Jacques Rousseau: portrait by Allan Ramsay, 1766. National Gallery of Scotland, Edinburgh. Photo Annan, Glasgow

page 50 Thomas Bewick, cat, wood engraving from his *General History of Quadrupeds*, 1790

page 55 William Blake, title-page of 'Night the First', from Edward Young's *Night Thoughts on Life, Death and Immortality*, engraving, 1797, published by Richard Edwards. British Museum, London. Photo R. B. Fleming

pages 59–64 William Blake, illustrations to the *Ode on the Death of a Favourite Cat*, pen and watercolour surrounding letterpress, 1797–98; actual size *c.* 42 x 32.5 cm. Yale Center for British Art, Paul Mellon Collection

page 65 Horace Walpole's Chinese porcelain tub (see above, *page 20, left*), and the original caption printed at Strawberry Hill in 1773

pages 71–76 Kathleen Hale, illustrations to the *Ode on the Death of a Favourite Cat*, pencil, ink and watercolour on paper, 1944. Private collection

page 80 William Hogarth, detail from *The Graham Children*, oil on canvas, 1742. The National Gallery, London. Presented by Lord Duveen through the Art Fund, 1934. Photo John Webb

SELECT BIBLIOGRAPHY

Ballaster, Ros *Fables of the East and Fabulous Orients* (Oxford, 2005)

Boswell, James *The Life of Samuel Johnson* (Harmondsworth, 1986)

Boswell on the Grand Tour: Germany and Switzerland 1764, ed. Frederick A. Pottle (London, 1953)

Calloway, Stephen, Michael Snodin and Clive Wainwright *Horace Walpole and Strawberry Hill* (catalogue, Richmond-on-Thames Libraries, 1980)

Clifford, Timothy *Cats on Handles* (British Antique Dealers' Association Yearbook, 1986, pp. 10–19)

Designs by Mr. Bentley for Six Poems by Mr. T. Gray (London, 1753)

Downey, James, and Ben Jones, eds. *Fearful Joy: Papers from the Thomas Gray Bicentenary Conference* (Montreal and London, 1974)

Hazen, A. T. *A Bibliography of the Strawberry Hill Press* (New Haven, 1942)

Hodge and other Cats (Harmsworth booklet of Dictionary extracts, London, 1996)

Holmes, Richard *Sidetracks/Dr Johnson's First Cat* (London, 2000)

Humphreys, A. R. 'Lords of Tartary' (*Cambridge Journal*, 1954, pp. 19–31)

Hutchings, W. B., and William Ruddick *Thomas Gray – Contemporary Essays* (Liverpool, 1993)

Jestin, Loftus *The Answer to the Lyre – Richard Bentley's Illustrations for Thomas Gray's Poems* (Philadelphia, 1990)

Johnson, Dr Samuel *A Dictionary of the English Language* (from the last folio edition, London, 1830)

Ketton-Cremer, R. W. *Horace Walpole* (3rd edn, London, 1964)

—— *Thomas Gray* (Cambridge, 1955)

Keynes, Geoffrey *William Blake's Water-Colour Designs for the Poems of Thomas Gray* (London, 1972)

Leigh, R. A. 'Boswell and Rousseau' (*Modern Language Review*, XLVII, 1952, pp. 289–318)

Lewis, W. S. 'The Genesis of Strawberry Hill' (*Metropolitan Museum Studies*, 5, 1934–36, pp. 57–92)

——, ed. *The Yale Edition of Horace Walpole's Correspondence*, 48 vols (New Haven and London, 1937–83: correspondence with

Gray, vols 13 and 14; *Patapan*, vol. 30, appendix 1; correspondence with Richard Bentley, vol. 35)

—— *Horace Walpole* (London, 1961)

—— *Rescuing Horace Walpole* (New Haven and London, 1978)

Lonsdale, Roger, ed. *Gray, Collins and Goldsmith* (London, 1992)

Mack, Robert L. *Thomas Gray – a Life* (New Haven and London, 2000)

Mason, William *The Works of Thomas Gray with Memoirs of his Life and Writings*, 2 vols (London, 1814)

Mowl, Timothy *Horace Walpole – the Great Outsider* (London, 1996)

Nicholls, G. *Dr Johnson's Cats* (London, 1998)

Pattison, Robert 'Gray's Ode on the Death of a Favourite Cat' (*University of Toronto Quarterly*, 49, 1979–80, pp. 156–65)

Plumb, J. H. *Sir Robert Walpole, The King's Minister* (London, 1960)

Porter, David 'From Chinese to Goth: Walpole and the Gothic Repudiation of Chinoiserie' (*Eighteenth Century Life*, 23, February 1999)

Sabor, Peter, ed. *The Works of*

Horatio Walpole Earl of Orford, vols I and IV (London, 1999)

Smart, Christopher *Cat Jeoffrey* (illustrated by Peter Hay, Reading, 1999)

Starr, H. W., and J. R. Hendrickson, eds *The Complete Poems of Thomas Gray* (Oxford, 1966)

Tayler, Irene *Blake's Illustrations to the Poems of Gray* (New Jersey, 1971)

—— 'Two Eighteenth Century Illustrators of Gray' (in Downey and Jones, pp. 119–26)

Tillotson, Geoffrey *Augustan Studies* (London, 1961)

Toynbee, Paget, and Leonard Whibley, eds *Correspondence of Thomas Gray*, 3 vols (Oxford, rev. edn 1971)

Vaughan, Frank A. *Again to the Life of Eternity – William Blake's Illustrations to the Poems of Thomas Gray* (London, 1996)

Walsh, Marcus, ed. *Christopher Smart – The Religious Poetry* (Manchester, 1979)

Williamson, Karina, and Marcus Walsh, eds *Christopher Smart – Selected Poems* (Harmondsworth, 1990)

Zuffi, Stefano *The Cat in Art* (trans. Simon Jones; New York, 2007)

INDEX

ॐ

Numbers in *italic* refer to pages on which illustrations appear.

Archer, Mary 43
Arnold. Matthew 40

Bentley, Richard 31–32; and publication of the *Ode on the Death of a Favourite Cat* 20, 24, *25*, 31–39, *34–37*, 40–41, 54; and Strawberry Hill 31, 41, 42, *42*
Bewick, Thomas *50*
Blake, Catherine 55
Blake, William: designs for the *Ode on the Death of a Favourite Cat* 54–58, *59–64*; designs for Young's *Night Thoughts* 54, 55, *55*
Boswell, James 6, 9–10, 41, 44–49, *45*
Britten, Benjamin 53
Burney, Dr Charles 11

Cambridge 6: Gray at 24, 25, 41, 43; Smart at 48, 49; Walpole at 11, 21; King's 21; Pembroke 27, 43, 49, 50; Peterhouse 12, 24, 25, 41, 43, 49; Trinity 6, 31
Carrington, Noel 66–70
Catullus 28
Chambers, Sir William 23
China and Chinoiserie 19–23
Chute, John 15
Clark, Sir Kenneth 40
Clinton, Henry Fiennes, Earl of Lincoln 14

Coleridge, Samuel Taylor 41

Damer, Anne Seymour 42
Dodsley, Robert 27, 28
Dryden, John 28

Eton College 12, 14, 25, 29

Flaxman, John 54, 56
Flaxman, Nancy 54, 56
Fox, Henry 22

Garrick, David 48
Gay, John 28
George (goldfish) 7
Gibbon, Edward 10
goldfish: fashion for 21
'goldfish bowl' in which Selima drowned 19–21, *20*, 23, 41–42, *42*, *65*
Goldsmith, Oliver 23
Gray, Thomas 24–25, *25*, 29, 40; with Walpole on Grand Tour 12, 13, 25; and the *Ode on the Death of a Favourite Cat* 6, 24–43, (commissioned by Walpole) 24–25, (the poem) 26–31, 40–41, 43, (Bentley's publication) 31–33, 39
Griffoni, Marchesa (Elisabetta Capponi) 13, 14

Hale, Kathleen 66–70, *71–76*
Hodge (Dr Johnson's cat) 9–10, 47, (Trinity College cat) 6, 7
Hotham, Henrietta 16
Houghton Hall, Norfolk 12, 13

John, Gwen 69
Johnson, Dr Samuel 6, 8–11, *9*, 19; and cats 8–10, 17, 28, 47–48; *Dictionary* 8, 17, 21, 28, 47–48; on Gray's *Ode on the Death of a Favourite Cat* 40–41; *Lives of the Poets* 40, 41; on Rousseau 46–47; and Walpole 10–11, 40

La Fontaine, Jean de 13, 14, 16
Leigh, Ralph 6, 7
Lyttleton, Hon. George 27

Mason, William 19, 42, 50
Masters, Mary 28
Milton, John 28, 54
Montagu, Mrs Elizabeth 41

Onslow, Arthur 14, 15, 39
Ovid 28

Patapan (Horace Walpole's dog) 13, 15, 16
Patapan (story) 13–15, 39
Pope, Alexander 15–16, 18, 28, 39, 48

Rousseau, Jean-Jacques 6, 44–47, *44*, *45*
Rowe, Nicholas: *Tamerlane* 17–19

Selima (Horace Walpole's cat) 17, 19, *20*, 24, 25, 26, 30, *34–37*, 42
Seymour Conway, Lord Francis 12

Seymour Conway, Henry 15, 23
Shakespeare, William: quoted 8, 47, 48
Smart, Christopher 43, 48–53
Smollett, Tobias 27

Thrale, Hester 10

Virgil: *Aeneid* 18, 24, 28
Voltaire: *Zaire* 19

Wain, Louis 68
Walpole, Horace *2*, 6–7, 10–11, 12; on Grand Tour 12–13, 25; at Arlington Street 17, 19, 21, 25; at Berkeley Square 17; at Strawberry Hill *11*, 16, 21, 22, 41, *42*; and Chinese fashion 19–23; and cats 11, 17, 19, 24; and dogs *11*, 12–15, 23; and goldfish 21; and Gray's *Ode* 24–42
Walpole, Sir Robert 10, 12, 13, 14, 15, 17, 40
Wharton, Thomas 27
Wordsworth, William 41

Young, Edward 54, 55, *55*

Zama/Zara (Horace Walpole's cat) 19, 24, 42

❖❖❖❖❖❖❖❖❖❖❖❖❖❖❖❖❖❖❖❖❖❖❖❖

This detail from William Hogarth's portrait of The Graham Children – *painted in 1742, five years before the death of Selima – has become the best-known image of a cat in the history of British art. The tabby-cat is staring – fascinated, ready to pounce, claws out, mouth open to inhale the scent – at a terrified goldfinch in a cage, whose fluttering is attributed by the innocent child below to his playing of a mechanical organ.*